FOR THE LOVE OF LETTERPRESS

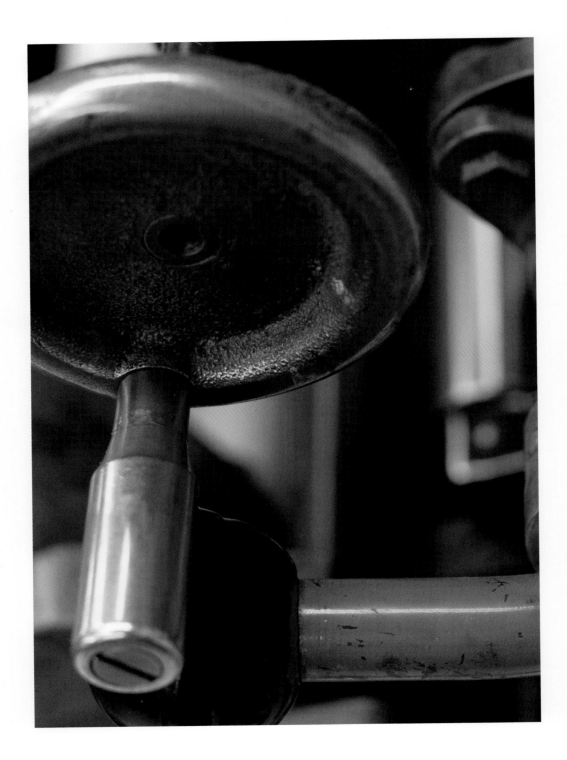

For the Love of Letterpress

A PRINTING HANDBOOK
for INSTRUCTORS & STUDENTS

Cathie Ruggie Saunders & Martha Chiplis

BLOOMSBURY

LONDON · NEW DELHI · NEW YORK · SYDNEY

*To Muriel Underwood, who fell in love with letterpress
in 1954, and is still in love today.*

First published in Great Britain 2013
Bloomsbury Publishing Plc
50 Bedford Square
London WC1B 3DP
www.bloomsbury.com

ISBN: 9781408139417

A CIP catalogue record for this book is available from the British Library

Commissioning editor: Susan James
Project manager: Davida Forbes
Copy editor: Ellen Grace

Photography by John Dunlevy unless otherwise stated.

This book is produced using paper that is made from wood grown in
managed, sustainable forests. It is natural, renewable and recyclable.
The logging and manufacturing processes conform to the environmental
regulations of the country of origin.

Printed and bound in China

Acknowledgements

Little did I know in 1985, that the student in the SAIC Type Shop working on her first book, *To Be Read Aloud*, would be my co-author twenty-seven years hence. Thank you, Martha, for your limitless research skills, your digital dexterity, and unwavering optimism.

Appreciation to John Dunlevy for his photographic eye and masterful hand with a camera.

Tom and Margaret Chiplis, for housing a 1,200 pound hunk of Vandercook press for so many years on their front porch.

Glenn Humphries for sharing the printed treasures of the Harold Washington Library Special Collection with us.

All of the artists whose letterpress work grace these pages.

The Riverside Library, an Arts and Crafts architectural beauty, saw us through first drafts, multiple revisions, jurying of images, design and final edits. Empanadus and Aunt Diana's Chocolates filled us up (deliciously) when we were spent.

Immeasurable gratitude to the School of the Art Institute of Chicago and the Visual Communication Design Department, for maintaining the commitment to letterpress in the education of artists and designers all of these years.

Gratitude to Susan James, for seeing the possibility of this book within us. And to Davida Forbes, for her editorial help in bringing it out of us.

Thank you Cathie, your stubbornness and warmth have allowed the Type Shop to thrive. You have been an inspiration to me and to so many others, to work harder than you ever thought you could, and to follow your heart.

And to our students: past, present, and to come.

Contents

CHAPTER ONE *The Sensual, Printed Artifact*

Imagine an erratically shaped room, tucked in the corner of the top floor of a 110 year-old building in downtown Chicago. Crowned with a pristine, steel-reinforced, modernist skylight that spans a quarter of the ceiling, brightness streams down. Clouds pass by. Skyscrapers tower as silent next-door neighbors, vanishing upward.

Inside that space, another illumination of sorts takes place. A fifteenth century printing technology is alive, and being introduced to twenty-first century students. This is the School of the Art Institute of Chicago's (SAIC) Letterpress Studio, under the auspices of the Visual Communication Design Department.

(Left) The two windows of the SAIC Type Shop

Professing an interdisciplinary curriculum, students from a myriad of departments walk through this door: Printmedia, Sculpture, Ceramics, Fiber and Material Studies, Painting and Drawing, Performance, Architecture, Interior Design and Designed Objects, Writing, Photography, Film, Video, New Media and Animation, Visual and Critical Studies, and, of course, Visual Communication Design.

What brings them here? Young adults who have grown up with microchips, Google and pull-down font menus are often unaware they can be simultaneously drawn to lead, tin, antimony and copper. At first glance, it might seem contrary to the speed-of-light attention spans they have perfected, to stand at a type cabinet and plink, plink, plink one character at a time into a composing stick. But very quickly they recognize it as a welcome antithesis, deepening their spectrum of concentration. Semester after semester, we have a full house. Three sections of a dozen students each, all yearning for something.

The Allure

We ask them that question on the first day. And the answers are remarkably similar.

Some come, bored and alienated with the digital environment. They long for an activity that slows the blind pace of auto-spacing and default kerning, and demands a rhythmic unity of mind and hand. In a more palpable sense, they want all of their senses to be engaged. Not just eyes reading a screen, but fingers touching and choosing an em space or an en space or a three to the em space. They want to pull a spatula through a viscous dollop of ink and watch it stream from the blade in a slow, molasses-like dance. The scent of a Type Shop is unmistakable, and indelible. Bicep-building drawer lifting will be their calisthenics for the next sixteen weeks. Working and studying in a Type Shop is a whole body experience, not for the lethargic or faint of heart.

(Top) The skylight.

(Bottom) Entry to
Type Shop.

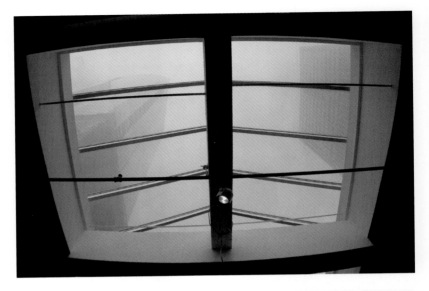

Undoubtedly there is an innate human attraction to letterpress. We could go so far as to say "seduction" even. "Love at first glance." Seeing the sculptural depth that a well-printed piece displays is enough to "take one's breath away." Turning the piece over and running one's finger across the line of impression penetrates the skin as well as the eye, the mind, and heart. There is little pleasure greater than the satisfaction gleaned from the humble punch of metal into paper.

Other students come, wanting to learn the basics of typography via a hands-on approach. Mystified by a vocabulary that they use daily, a vocabulary they do not know the origins of, posits a doubt in their mind. They sense that they should know something, but they aren't sure what. Why is it called leading? Why is a typical paragraph indentation considered an "em" space? "Really now, do you think you can teach my eye to discern the difference a hair space makes in kerning two characters?" Holding a ligature in one hand, and both individual characters in the other, might be the first time they touch—and thus understand—the improved aesthetic spacing. They witness the clarity of the sculpture in their hand, and "see" with their fingertips as well as their eyes.

There is an historical enticement as well. These students join hundreds before them, each a link in a chain that stretches back more than 500 years. Extending beyond Aldus Manutius to Johannes Gutenberg in the Western World, and even farther in the Eastern, these distant relatives will become closer and more familiar as they touch an italic, or gaze at a page of the 42 line Bible. And each time they dip their hand into a California case, they withdraw the same type that veteran compositors—both commercial and hobbyists—have used before them. What will they spell out with the same font used by R.R. Donnelley and Sons, a time-honored Chicago publishing company? Or with the type that won Sherwin Beach Press international recognition in the Ninth Biennial Carl Hertzog Book Design Award Competition?

Even just caressing the old lead characters retrieved from the garage of an 89 year-old World War II pilot can conjure up inspirational images. Every book tells a story, but every California case has many, many stories to tell.

Some students come through our doors searching for a means of incorporating image and text. They might have been working with both in their studio practice, or even just one, and have come to a point where a more unified bonding of the two is necessary to lift their work to a higher level. Writers enter seeking a way to visually present their words in a more physically aesthetic manner. Bookbinders, proficient with structural formats, come seeking the means

to place content on those pages. Printmakers, tired of straining to write backwards on intaglio plates and litho stones, embrace the forward movement of job stick composition.

The resurgence of the media of letterpress over the past few decades has also fueled our enrollment ranks. Curiosity about how these cast iron presses can transfer the delicacy of a hairline serif onto paper gets the better of them. The spectacle of their friend hauling a 1 ½ ton hulk of metal into his basement demands explanation. Even the thrill of winning an eBay auction for a vintage printer's cut will require a "proof," and once ink is under their fingernails, they are smitten.

Other faculty members speak of it as a "good elective" for artists and designers. Each semester, as a recruitment device, we host visits or short workshops for their students to become acquainted with the Shop. Of course we publicize across the campus with hand-printed flyers that are literally ripped down within hours of their posting. Some converts are gleaned from reviewing class evaluations at the Office of Student Affairs, but word of mouth—from student to student—is a faster channel of information. Certainly some just come because they heard "it was fun." And indeed it is.

The Passion

Once inside the Type Shop students see a carefully organized studio, replete with vintage as well as contemporary equipment. Just as importantly, they are introduced to instructors and teaching assistants convinced of the relevance of this media to their educational experience and the development of their artistic vision.

It is no easy task to campaign for space, budget and curriculum inclusion in an academic culture strapped for floor space, suffering from a tight economy, and wary of increasing the requisite number of credits a student must take to graduate. Tuition dollars most often dictate career pertinence and high profile visibility. Letterpress has waxed and waned within societal, commercial, and academic contexts. Persistence and persuasion have proven to be an indomitable strategy in our efforts to keep 15 ½ tons of metal actively engaged within the hands of our students. Conveying the applicability of letterpress to other departments, and enlisting them as allies has proven invaluable. And a supportive administration has been indispensable.

But most essential is the passion modeled by the individuals that work in the Type Shop every day. This begins with instructors who love the media and love to teach it. It continues with Teaching Assistants and intermediate and advanced students who have

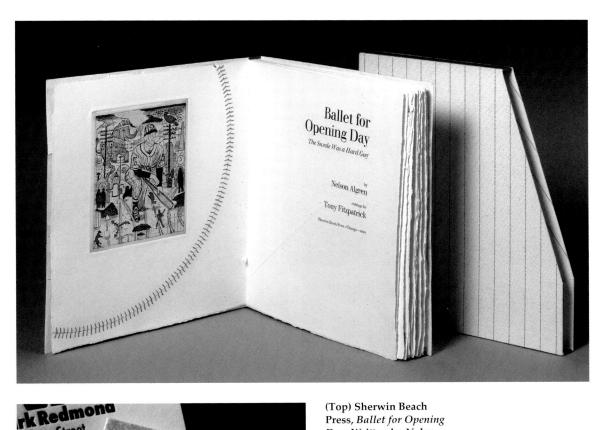

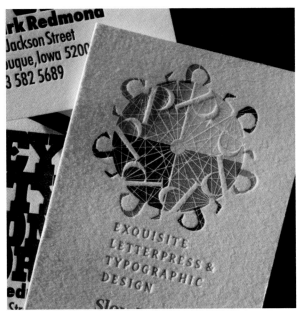

(Top) Sherwin Beach Press, *Ballet for Opening Day*. Written by Nelson Algren. Illustrated with etchings by Tony Fitzpatrick, printed at Big Cat Press. Text printed by Martha Chiplis on Twinrocker papers in Monotype Walbaum, set by Michael Bixler. Designed by Robert McCamant and bound by Trisha Hammer. 2002. (11" x 10" x 5½".) Photograph by Jack Kraig.

(Left) Peter Fraterdeus, SlowPrint business card design 2010–2011. (3½" x 2".) Photograph by Peter Fraterdeus.

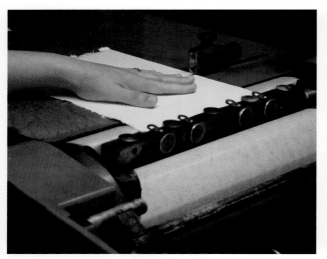

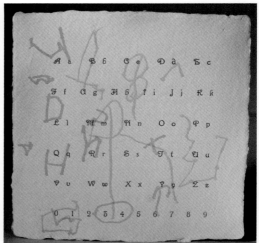

emerged from one or more semesters of learning in the Type Shop. They simply "feel it in their bones" that they need to continue to be there, exploring more thoroughly all that it has to offer, and sharing those discoveries with beginners.

As for me, I love letterpress because I love books. My father, a man of few (spoken) words, read voraciously. As a child, I remember his bookshelves in the living room, filled with leather bound tomes, gilt edges, a satin ribbon trailing down each spine. Dad refused to paste a bookplate between the covers, or place a book back on the shelf, until he had read through to the last page. The action of pasting the bookplate was a tacit agreement with that book that his hand had touched every page, his mind had considered every thought, and now it was time for the next individual to delight in what was between its covers. Many of those cherished books now stand on my bookshelf.

I love letterpress because I love language. Typography is the vivification of language. Letterforms, alphabets can speak of Shakespearean sonnets or nursery rhymes. When my daughters were first straining to scratch out their ABCs with pencils in their tiny hands, I was overwhelmed with the beauty and consequence of their attempts. One of my favorite broadsides resulted from that moment of tender acquisition in their lives.

I love the materiality of holding a character in my hand and assembling a row of "lead soldiers."[1] Tying up forms and tucking them into the galley until it is nearly too heavy to lift. The smell of ink. The pristine field of paper about to be kissed by an arabesque of a Garamond swash. Leafing through a stack of freshly printed pages in an edition is as thrilling as a child "unwrapping" Christmas morning.

I love how it engages all of me. Eyes delighting in exact kerning. Fingertips sensing the perfect punch. Hands sliding a sumptuous sheet precisely under the grippers. Feet stepping in parallel cadence with the carriage as it rolls across the bed. Ears tuned to the click/clack of the cylinder, a rhythmic heartbeat, synchronized with mine.

They say printer's ink gets in one's veins. This is not a health and safety warning. Printing has a way of reaching deep inside and touching that innate human urge to "make" marks, and "leave" one's mark. The Lascaux cave paintings attest to the former. Stone-carved epitaphs attest to the latter. If, as Horace says, "the written word remains,"[2] I believe there will always be printers that want to commit that word to paper.

It is this historical legacy that I feel connected to in the studio, a process that was fundamental to the cultural evolution of the world. In a humbler context, it speaks to what I love best: sharing ideas. Most undergraduate students now have lived with computers all of

"Letterpress requires one to be thoughtful, to plan, to stretch, and I love work that is considered in this way. So much in the world today is not…I am also a believer that newer is not always better, faster is not deeper, and that process is as important as product. Letterpress addresses each of these concerns in different, and incredibly rich, ways. I also feel passionately about our collective need to slow, to breathe, and, as creative people, to work with processes that do not require any other electricity than that provided by our bodies."
—Amara Hark-Weber, SAIC Teaching Assistant

(Top left) Hand on feedboard.

(Top right) Cathie Ruggie Saunders, *R & S Alphabet Broadside*, hand set in Electra; printed on Twinrocker handmade paper. 1992. (6 ⅝" x 6 ⅝".)

(Bottom) Philippa Wood. *Done* Letterpress and silkscreen printed on tissue paper. Unique. 2008. (10" x 8 ½" x ½".) Photograph by Philippa Wood.

their lives. For them to have the experience of creating a book from concept to layout to production, with lead type, paper, ink, thread, book cloth, and glue, engenders a level of ownership and engagement that is rarely attainable elsewhere. Every aspect is a choice they make. Every decision is the result of a series of actions that rely upon one another, build upon one another. Guiding them in their plans, watching them problem-solve and trouble-shoot, dialoguing every step of the way is where my love of furthering this media comes in. Teaching letterpress celebrates literacy, history, creativity, and the sensual artifact.

Inherent in this pedagogy is a dynamic reciprocity. As instructors we are communicating our expertise, challenging our students to think critically and imaginatively. But the act of learning continues to occur within us as well. Each time I am asked a probing question to which I do not know the answer, I am compelled to do research. And, I am energized by the acumen of the student. In conversing with them one-on-one, we often excavate a concept that stimulates *me* to create a book. Composing each semester's new syllabus I am insistent upon developing improved projects, incorporating more historical references, and initiating more interactivity with contemporary processes.

Could it be that the allure of letterpress and the passion for its practice reaches even deeper than we imagine? Could it permeate our subconscious? After Martha had taken her first semester of letterpress with me, she did not register for it the following semester. One night, well into that next semester, she had a dream. She was standing in the Type Shop, surrounded by type cabinets and printing presses. I was there, in the Shop in her dream, and asked her why she hadn't come back. At that moment, she realized, this is what she was meant to be doing.

Could it be encoded in our DNA? As a toddler, each time Martha visited her grandfather, a photo-engraver by trade, instead of playing with Lincoln Logs or Lego, she pulled out a box of wood furniture that he kept under his chair, building structures that children and printers alike would love. Two decades ago, I had been making frequent trips to retrieve donated type for the School, each time packing up my twin daughters in our van, and squeezing type cases in between them and behind them. Once, when they were not quite four, I carefully placed a drawer of Palatino swash capitals on top of the pile of cases in the back. Sarah peeked over the seat, reached her hand into the case, picked up a letter, and exclaimed: "Oh Momma, what a beautiful font!"

"It sure is!" I replied. And we headed home, treasure in tow.

Notes

1 "Give me 26 lead soldiers and I will conquer the world" is often attributed to Benjamin Franklin, but also Karl Marx, as well as an unknown French printer. http://typefoundry.blogspot.com/2007/05/with-twenty-five-soldiers-of-lead-he. html

2 Stone, Jon R. *The Routledge Dictionary of Latin Quotations.* (Abingdon: Routledge, 2005). Available at: http://books.google.com/books?id=rAXHv7KlHxMC&pg=PA 55&lpg=PA55&dq=Horace+quote:++%22The+Written+Word+Remains.&source=b l&ots=cz4mJBw4DQ&sig=cv9T9e1O9eWD6CupRaz1jw55Kbk&hl=en&sa=X&ei=_ SD-T7yUAdL1qAGwudSNCQ&ved=0CFYQ6AEwAw#v=onepage&q&f=false

CHAPTER TWO *The Historical Legacy: Connecting the Past and Future*

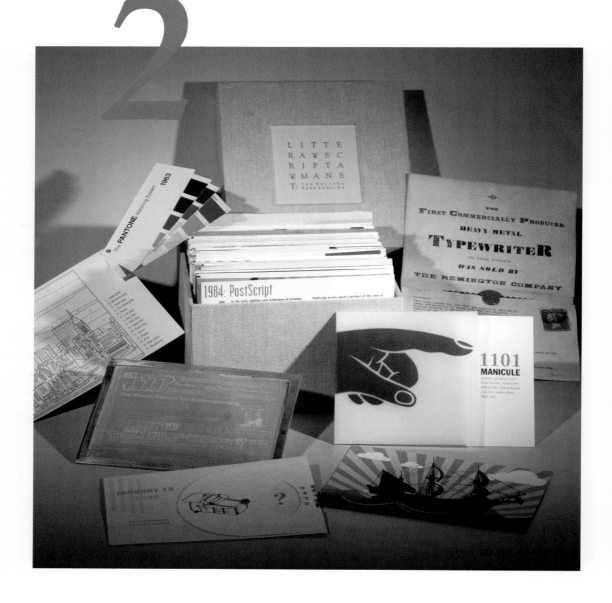

F rederic Goudy, born in Bloomington, Illinois, founded The Booklet Press[1] in Chicago in 1895 with equipment he bought from Will Bradley, who was also a resident of Chicago at that time.[2] In 1903 Goudy and Will Ransom,[3] another Chicagoan, started the Village Press[4] in Park Ridge, a close suburb northwest of Chicago. By the time of his death in 1947, Goudy had designed 123 typefaces, establishing himself as one of the best-known and most prolific type designers.[5]

Oswald Cooper, a printer's devil in Kansas at age 17, moved to Chicago and studied lettering with Frederic Goudy.[6] In 1918, his Cooper Old Style, designed for Barnhart Brothers & Spindler,[7] a well-known Chicago typefoundry, became the first typeface with rounded serifs.[8] His Cooper Black, "the boldest, blackest face ever to be released in type,"[9] designed in 1922, was "one of the most popular faces used in advertising during that period."[10]

After the American Type Founders' (ATF) takeover of BB&S in 1929, Cooper drew the basis of Boul Mich (named for Chicago's Michigan Boulevard.[11] In 1939 he dedicated time toward developing the corporate identity for the *Chicago Daily News* newspaper.[12]

Robert Hunter Middleton studied letterforms and type design under Ernst Detterer at the Art Institute of Chicago in the 1920s just as Detterer was implementing a new curriculum in the Printing and Typographic Arts Department.[13] During his 49-year career at Chicago's Ludlow Typograph Company, Middleton created one of America's most respected type libraries, designing almost 100 of the faces in the library himself.[14] Middleton was also influential in the revival of interest in the work of Thomas Bewick (1725–1828), the celebrated English wood engraver, whose work he printed at his Cherryburn Press in the city.[15]

Acquainting our students with these Chicago-based typographic luminaries instills considerable local pride, and positions them to understand the legacy Chicago has contributed to printing history. Examining a character from Goudy Oldstyle or Cooper Black or Coronet, font designs from each of these men respectively, students begin to comprehend precisely what Goudy himself expressed: "Each face has a spirit of its own. New types express the tempo of the times."[16]

Of course we hope this appreciation extends to our entire inventory. To facilitate that, index cards, with each font's designer, original foundry, date, etc. are placed in many of the California

(Left) Cathie Ruggie Saunders, Curator, *Littera Scripta Manet: The Written Word Remains.* Handmade Box by Linda Lee with letterpress printed title containing student-generated digitally printed cards. Each 5" x 7" card chronicles a specific aspect of the history of printing. 2012.

"At 40, this short, plump, pinkish and puckish gentleman (Frederic Goudy) kept books for a Chicago realtor, and considered himself a failure. During the next 36 years, starting almost from scratch at an age when most men are permanently set in their chosen vocations, he cut 113 fonts of type, thereby creating more usable faces than did the seven greatest inventors of type and books, from Gutenberg to Garamond."
—Andrew R. Boone[17]

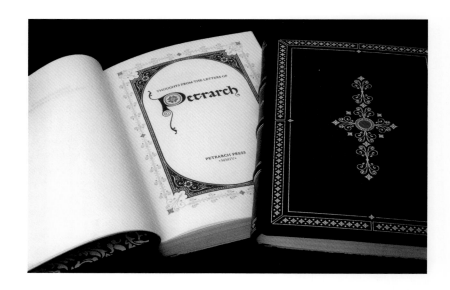

(Top) The Petrarch Press, *Thoughts from the Letters of Petrarch.* Set in Dante with Goudy Lombardic Caps. Printed on sheepskin parchment on an Albion press under the direction of William Bentley. Designed by Peter Cohen. 2004. (7⅞" x 5½" x 1".) Photograph by Keith Walley.

(Center) Robert H. Middleton, *Alphabet in progress.* Wood engraving. 1985. (9⅝" x 7¼".)

(Bottom) *The Essence of Beeing,* written by Michael Lenehan. Printed by The Sherwin Beach Press. Illustrations by Alice Brown-Wagner. Ornaments by Albert Richardson. Printed on Fabriano Roma in Cooper Oldstyle. Designed by Robert McCamant. Bound by Ann Repp. 1992. (12" x 9¼" x ½".) Photograph by Jack Kraig.

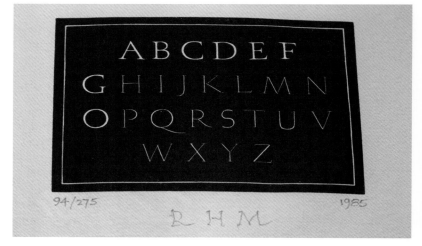

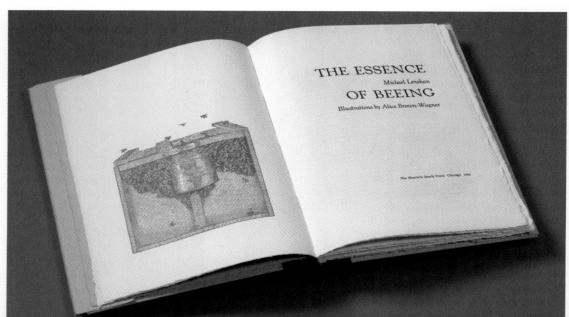

cases, providing a mini history lesson to each student who opens that drawer.

Project assignments also strive to instill knowledge of and respect for printing history. For many years now, each semester students are asked to create a double-sided, digitally printed card about an event, invention, or individual associated with printing history. The card is to be designed "in the spirit of the times," with the date prominently displayed on the front, resources cited on the back. Each card is then chronologically filed in an elegant box (handmade by a former teaching assistant), which serves as an archival timeline both significant and commonplace. Examples from our registry include the first use of the manicule in 1101[18] to "sea presses" that came over to the New World aboard ships in 1564,[19] and the first commercially produced heavy metal typewriter (1873)[20] to the invention of the Pantone Color Matching System in 1963.[21] The Archive is available in the Shop for students to peruse, and we are planning an installation exhibition of it, cards posted in a timeline format stretching around the walls of a gallery space.

A student's first semester in letterpress will include a project introducing them to two major historical design aesthetics: the classical and the modernist page layout. By setting and printing paired words, students learn to compose both centered and asymmetric layouts, understand the respective Roman and sans serif font use, and strive to relate the definition of each word to its appropriate format presentation. At critique, they are often awed by the powerful eloquence of a single word printed on a page. It serves as an excellent means of conveying the expressiveness of negative space, and the necessity to evaluate exactly what needs to be printed, and what doesn't. From this single sheet foundation, students carry these lessons on to their bookmaking projects throughout the remainder of the semester.

By extending learning outside the studio and viewing the abundant letterpress resources that the Chicago Public Library/Harold Washington Center and The Newberry Library have in their collections, students see original printed examples. These artifacts are able to imbue the viewer with insights about historical context, technical proficiency and design aesthetics in a manner more impressive than any PowerPoint presentation might do. With gloved hands they touch a page from the Gutenberg Bible, and peering sideways can discern the superlative imposition of that first piece of Incunabula.

The Arts and Crafts movement's emphasis on the handmade nature of the entire book object takes on utter clarity when a student holds William Morris' 1895 little gem *Child Christopher and Goldilind the Fair.* Here they can measure its intimate proportions with

(Top) The Petrarch Press, *Thoughts from the Letters of Petrarch.* Set in Dante with Goudy Lombardic Caps. Printed on sheepskin parchment on an Albion press under the direction of William Bentley. Designed by Peter Cohen. 2004. (7⅞" x 5½" x 1".) Photograph by Keith Walley.

(Center) Robert H. Middleton, *Alphabet in progress.* Wood engraving. 1985. (9⅝" x 7¼".)

(Bottom) *The Essence of Beeing,* written by Michael Lenehan. Printed by The Sherwin Beach Press. Illustrations by Alice Brown-Wagner. Ornaments by Albert Richardson. Printed on Fabriano Roma in Cooper Oldstyle. Designed by Robert McCamant. Bound by Ann Repp. 1992. (12" x 9¼" x ½".) Photograph by Jack Kraig.

Middleton was dedicated to improving the industry in which he worked. He co-founded the Society of Typography Arts in Chicago in 1927, and was involved in establishing the Institute of Design (the New Bauhaus) in Chicago in 1937. He was also a member of the 27 Chicago designers, organized in 1934, and he was a member of the Caxton Club for 40 years.[23] Middleton was among the first American members of the Association Typographique Internationale (ATypI) founded in Lausanne, Switzerland in 1957, which was one of the first proponents of typeface design protection.[24]

the palm of their hand; hear the crackle of the deckled handmade sheet as they turn a page; see the printed blackness of the hand-cast type and the beauty of the Golden Section spanning an open spread. How more apparent and evocative can these typographic and design attributes become? What greater incentive might there be to research William Morris than to physically encounter one of his sensual printed artifacts?

The current living generation of printing luminaries is part of the legacy we strive to honor and learn from as well. Muriel Underwood, an individual with the foresight to help establish a letterpress workshop in 1952 for the membership of the Society of Typographic Arts, continues to visit and print with the equipment that became our current shop's seminal donation.[25] The wealth of stories she has shared with our students, and the behavior she models—still setting type and printing at 89 years of age—is inspirational. If the United States had a similar tradition as Japan's designation of deserving elders as "national living treasures," Muriel would earn our vote.

Camaraderie and generosity are hallmarks of letterpress printers. Individuals who have been printers most of their lives have such an affection for the media, they often will quote an inexpensive price (or free!) for their used equipment just to see that it goes into the hands of a younger generation, willing to continue the practice. This is an excellent means by which serious students can begin acquiring equipment to set up their own shops. Schools that teach letterpress are grateful recipients of donations. Equipment or type that comes our way is listed by donor in our inventory of faces, and marked with a hand-printed label announcing its provenance.

Movable type, by definition, was a "recycling" innovation vastly more efficient than the earlier wood block-books.[26] Previously owned movable type confers another dimension upon that recycling concept. Young printers of today are re-using type from yesterday, creating books for the future. Libraries that have Special Collections are recognizing this and are adding both fine press and innovative artist's books to their holdings. Among the more than 4,000 artists' books, periodicals and multiples in the Joan Flasch Artists' Book Collection in the SAIC Flaxman Library, is a nascent collection of SAIC student work.

Awareness of the past informs the present. Appreciation of the past confers a responsibility upon the present to ensure this media's longevity into the future. With the accelerated momentum of digital printing technology, the continued vitality of letterpress relies upon an acknowledgement and utilization of the distinct characteristics of each. Preliminary font choices, tentative layouts, and color trials are frequently done on laptops, side by side with Vandercooks

For the Love of Letterpress

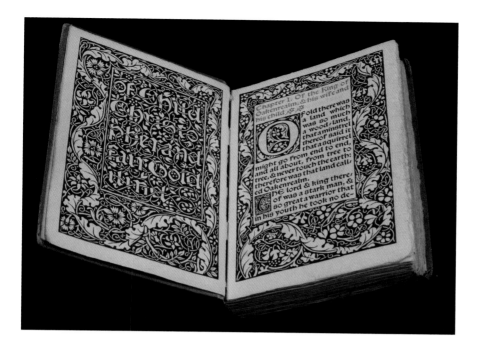

Indulgentia

№ 147

Всім вірним справі друкарській, котрі бачать складані літери сі, чорного мистецтва високого друку майстер Даубманнус привіт надсилає. Благословенний зачинатель справи нашої Йоган Гутенберг не може без тривоги та смутку споглядати кривди й утиски, що їх зазнають від е-інків, ай-падів, рідерів та інших недругів стародавнього ремесла друкарського славні нащадки його. Тому всякому й кожній, хто стане до бою за давнішнє ремесло наше супроти ворога недоброго, від імені й за дорученням щонайвищого і щонайчорнішого нашого майстра майстрів Йоганнеса Генсфляйша цур Ладена цум Гутенберга, буде даровано відпусту й прощення всіх помилок і хиб, хоч би які тяжкі та прикрі вони були.

През видіння, що навідало Іоана Опріона Гулкова, отця Каплиці М'якої Мармизи у Вест-Індії, Даубманнус записав відпусту сю. Опріч того до роботи сієї руку міцну доклали: характерник від літер Микола Вус та зацний майстер письмен готичних Антін Квілкрафт.

У Майстерні Даубманнуса, року Божого 2011, місяця травня, 8 числа — СКЛАДЕНО.

Форма повної відпусти помилок та хиб видавничих

Від імені й т. ін. відпущено й пробачено тобі помилки й хиба редакторські, коректорські, композиційні, верстальні, пре-пресові, а заразом всі типографійні вади: шрифтові зльоти, лапки й апострофи кепські, дефіси за тире, пробілів надмір, чи й гірше—коміксансові неподобства. Нехай зазнають викриття всі вади на префлайті, а наклад най відбуде щасливо всі кола друку.

Форма повної відпусти недоглядів і вад друкарських

Від імені й т. ін. відпущено й пробачено тобі недогляди й вади друкарські: кепське зведення, різнотони, муари й заливку нещільну, а заразом зле порізані, зшиті і проклеєні вироби. Нехай ніщо не зіпсує доброго гумору замовника твого і читачів літер твоїх.

Johannes Gutenberg & Officina Daubmanni

(Top right) *Child Christopher and Goldilind the Fair.* Printed by William Morris. 1895. Courtesy of Chicago Public Library, Special Collections.

(Bottom right) Fedir Shulga of Officina Daubmanni, *Indulgence in the Name of Gutenberg.* Hand set with Literaturmaya, Obyknovennaya, and No. 3 metal fonts. Calligraphy by Anton Mizinov. Editing by Mykola Kovalchuk. Thanks to Ivan Gulkov. Printed in Kyiv on a Chandler and Price press. Based on a 31-line Letter of Indulgence from 1454, revised as an absolution of typographical sins given to any practitioner of the black arts. 2011. (8" x 8¼".) Photograph by Irina Kouyan.

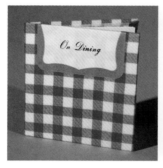

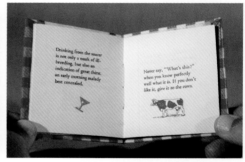

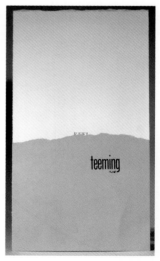

and Chandler & Price presses in the Type Shop. Students consult search engines as their book concepts multiply, and research is done immediately, without breaking stride to walk to the library. Adobe Illustrator is at home here as is the old-fashioned method of bending leading to shape a curved type form. Running out of type to set a page? Budget conscious solution: print, distribute, and set again. Time at a premium? Set it digitally and have a plate made. Or even faster, send your digital file to the laser cutter and make a relief matrix yourself. Color choice for ink? You will get a better lesson in color theory by opening ink cans and making draw downs than clicking on a drop-down color menu. How does Hosho paper respond to the pressure of letterpress? Proof on a swatch of it. Or look in the drawer of student work for an example "in real time," and "actual size," close up and in detail. Complicated lock-up? Snap a picture of it with your smart phone, or draw a quick diagram, strengthening your skills at furniture and reglet recognition.

Co-existence is letterpress's best hope for the future. By emphasizing the attributes of both digital and analog printing technologies, one can make an informed choice as to which best complements their intended concept. Connecting the present generation of novice letterpress students with the elder generation of practitioners will help ensure its longevity into the future. Knowledge about the historical significance of this major invention which "ignited the explosion of art, literature, and scientific research that accelerated the Renaissance and led directly to the Modern Age,"[27] will help create citizens cognizant of the communicative potential of the printed word.

(Top) Muriel Underwood next to her Sigwalt press.

(Center left) Muriel Underwood, *On Dining* (cover). From an article in Inland Printer 1911. Letterpress printed on Mohawk Superfine using a Sigwalt tabletop press. Set in 10 pt. Centaur. Bound in red and white checked dress cloth. 2002. (3" x 2¾".)

(Center right) Muriel Underwood, *On Dining* (spread).

(Bottom left) Rebecca Workman, *Pineapple*. 2012. (6" x 9".)

(Bottom right) Emma Weber, *Keel/Teeming*, Baskerville and Phenix on Arches and Canford paper. *Keel/Teeming* is an exploration into the relationship that two words can have together. A keel is an ancient fishing boat that rides very low in the water. Teeming, in this context, is meant to be the abundance of fish below the keel. An additional squiggly ornament suggests movement of sea life and water. 2012. (11" x 6".)

Notes

1 Later renamed The Camelot Press. David Consuegra, *Classic Typefaces: American Type and Type Designers* (New York: Allworth Press, 2011), 141.

2 Proprietor of Wayside Press, poster artist, book, magazine and typeface designer. Consuegra, *Classic Typefaces: American Type and Type Designers*, 96.

3 Designer of Parsons typeface, which he named for I.R. Parsons, an advertising manager for Carson's Department Store, and used in all of Carson's ads for many years. It was also among the most frequently used faces in motion picture titles and captions. James M. Wells, *Will Ransom* in *Heritage of the Graphic Arts*, ed. Chandler B. Grannis (New York & London: R.R. Bowker Company, 1972), 109.

4 One of the first private presses in America and a popular meeting place for many important figures in the Chicago art world at that time. Neil Macmillan, *An A-Z of Type Designers* (Connecticut: Yale University Press, 2006). 154.

5 Macmillan. *An A-Z of Type Designers*, 92.

6 Consuegra, *Classic Typefaces: American Type and Type Designers*, 116.

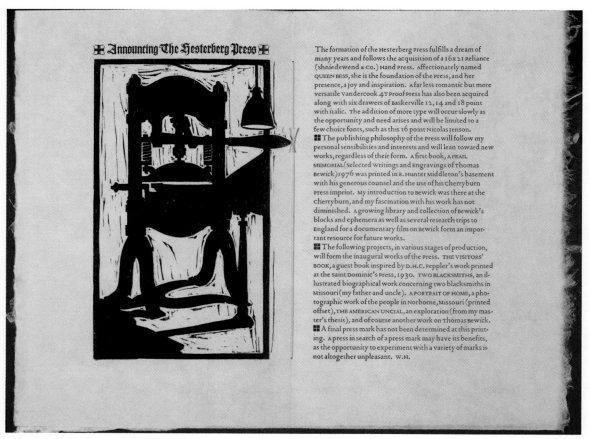

The formation of the Hesterberg Press fulfills a dream of many years and follows the acquisition of a 16 x 21 Reliance (Shniedewend & Co.) Hand Press. Affectionately named QUEEN BESS, she is the foundation of the Press, and her presence, a joy and inspiration. A far less romantic but more versatile Vandercook 4T Proof Press has also been acquired along with six drawers of Baskerville 12, 14 and 18 point with italic. The addition of more type will occur slowly as the opportunity and need arises and will be limited to a few choice fonts, such as this 16 point Nicolas Jenson.

■■ The publishing philosophy of the Press will follow my personal sensibilities and interests and will lean toward new works, regardless of their form. A first book, A FRAIL MEMORIAL (selected writings and Engravings of Thomas Bewick) 1976 was printed in R. Hunter Middleton's basement with his generous counsel and the use of his cherryburn press imprint. My introduction to Bewick was there at the cherryburn, and my fascination with his work has not diminished. A growing library and collection of Bewick's blocks and ephemera as well as several research trips to England for a documentary film on Bewick form an important resource for future works.

■■ The following projects, in various stages of production, will form the inaugural works of the press. THE VISITORS' BOOK, a guest book inspired by D.H.C. Peppler's work printed at the Saint Dominic's Press, 1930. TWO BLACKSMITHS, an illustrated biographical work concerning two blacksmiths in Missouri (my father and uncle). A PORTRAIT OF HOME, a photographic work of the people in Norborne, Missouri (printed offset), THE AMERICAN UNCIAL, an exploration (from my master's thesis), and of course another work on Thomas Bewick.

■■ A final press mark has not been determined at this printing. A press in search of a press mark may have its benefits, as the opportunity to experiment with a variety of marks is not altogether unpleasant. W.H.

7 Opened in Chicago in 1873 as the Great Western Type Foundry, it became
 BB&S in 1883. www.myfonts.com/foundry/Barnhart_Brothers_and_Spindler

8 Consuegra, *Classic Typefaces: American Type and Type Designers,* 116.

9 Allan Haley, *Typographic Milestones.* (New York: Van Nostrand Reinhold, 1992),
 82.

10 Consuegra, *Classic Typefaces: American Type and Type Designers,* 116.

11 Haley, *Typographic Milestones,* 83.

12 www.linotype.com/351/oswaldcooper.html

13 Consuegra, *Classic Typefaces: American Type and Type Designers,* 194.

14 Haley, *Typographic Milestones,* 122.

15 Macmillan, *An A-Z of Type Designers,* 135.

16 Andrew R. Boone, "Type by Goudy". *Popular Science,* April 1942, 119.

17 Andrew R. Boone, "Type by Goudy". *Popular Science,* April 1942, 114.

18 William H. Sherman. "Toward a History of the Manicule." March 2005.
 Available at:http://en.wikipedia.org/wiki/Index_(typography)

19 www.heartsandanchors.com

20 http://staff.xu.edu/polt/typewriters/tw-history.html

21 www.pantone.com

22 Allan Haley, *Typographic Milestones.* (New York:
 Van Nostrand Reinhold, 1992). 78.

23 Consuegra, *Classic Typefaces: American Type
 and Type Designers,* 194.

24 Haley, *Typographic Milestones,* 122.

25 The *Caxtonian.* vol 5, #5, May 1997.

26 Geoffrey Dowding, *An Introduction to the History
 of Printing Types* (London, UK & DE, USA: The
 British Library & Oak Knoll Press, 1998), 3.

27 John Man, *Gutenberg: How One Man Remade the
 World with Words* (New York: John Wiley &
 Sons, 2002), book jacket.

Fifteen years ago we accepted a donation from the daughter of a printer who had passed away. It is a beautiful collection of vintage type, carefully and obviously lovingly documented with the name of each typeface, foundry, and even purchase price. I kept these records and two years ago, a young woman walked into the Type Shop and introduced herself as that printer's granddaughter. She remembered working with him in his basement shop as a child and wanted to see where his equipment had gone. I could show her everything. Interestingly, she is a professional designer herself. She emailed her entire family with pride: she had seen how Grandpa's type is still alive, in the hands of a new generation of student printers.

Atelier
Eröffnung
Bleilaus

CHAPTER THREE *Printer's Primer*

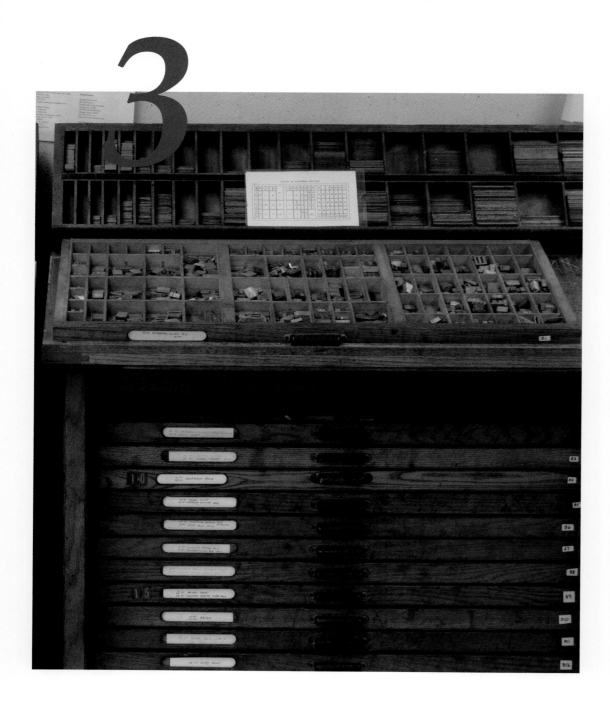

Whan students enter the shop on the first day, they don't re-
alize the minutiae involved in letterpress printing. As we
begin, we walk around the shop, showing and naming the many
tools and materials they will be working with during their time
there. Galleys, galley cabinets, type cabinets, type cases, type, com-
posing sticks, pica rulers, spacing, leading. These are the terms they
need to start.

 After the discussion of shop rules and the shop tour, we begin
the discussion of the type case and parts of type. Type-high, nick,
points, picas, face, body. One piece of type from ATF, or from Acme
in Chicago, or cast on a Ludlow or Thompson caster by a Chica-
go job printer, represents part of the history of printing and type
design. One piece of type represents the height of mechanization —
reached and then made obsolete for almost all of commercial print-
ing after about 1980.

(Left) Type cabinet with
leading rack and a full-
size California Case.

Terminology and Measurement

By necessity, the beginner must learn in increments. A student can't
learn all of the terms she will need to know on the first day. But
by repeated exposure to the correct terminology, the beginner will
eventually become familiar with the words and use them with ease.

 Points and picas are the units of measurement used in the Type
Shop. There are approximately 12 picas per inch, and 12 points per
pica. A metal line gauge, marked with inches, picas, and points, is
the printer's ruler.

Lay of the Case

A large number of different type case layouts have been used since
Gutenberg, but the California Job Case is the most commonly used
layout in the United States. One California case is designed to hold
one size of one typeface (for example 12 point Bodoni Book). The
full-size California case has been in production since the 1870s.[1] The
major innovation of the California case is that it combined upper
and lower case letters with punctuation and numerals into one case.
Before the California case, upper and lower case letters were in two
separate cases, one placed above the other, hence the terms "upper"
and "lower" case. In the California case, the caps are arranged in the
right half of the case in alphabetical order, except the J and the U,
which come after the Z. Although the J and U were added to the Ro-
man alphabet before the invention of the California case, the order
of the caps was never changed.

The Point System

In 1874, John Marder of Marder, Luse & Co. Type Foundry in Chicago persuaded inventor and printer Nelson C. Hawks to go to San Francisco to establish a branch. Marder also asked Hawks to become a partner. At the time, type sizes from different manufacturers almost never matched each other; they each had their own proprietary way of sizing their types. Because of the non-interchangeable type sizes, spacing especially was a challenge. Can you imagine having separate spacing for each brand of type you own, for every size? It was great for the type foundries, since it encouraged brand loyalty. For the printer, it was a problem.

Hawks seriously considered the need for uniform type bodies. When Marder visited Hawks in San Francisco for the first time in 1877, Hawks convinced him of the viability of the new system of type bodies. But there had to be a change to Hawks' original system. The size of the pica was still in question. The pica used by Hawks (and a minority of type founders) was exactly 1/16 of an inch.

You might wonder, why not put the caps in alphabetical order now? The J and the U were added to the Roman alphabet generations ago. Perhaps it is the time investment required in changing an entire print shop of cases, sometimes hundreds, which prevents printers from doing so.[2]

On the lower case side, letters and punctuation are placed in differing sized compartments based on their frequency of use. Since the letter "e" is used the most, it receives the largest compartment, which descend in size from there.

Type set by hand from a case was the primary method of preparing texts for printing from Gutenberg until the late 1800s, when the invention of the Linotype and the Monotype superseded it. Because of this, there are many different case layouts. Every language with a written system needed an organizational system for its case. Chinese, with over 8,000 symbols, is especially difficult to set by hand in metal type.

One alternate case layout currently in our Type Shop is the ⅔ case. It is smaller than the California case, and has two sections in it instead of the three of a full-size California case. The section holding the lowercase letters is the same as in a full size case, while the caps are arranged behind them at the back of the case. Another case layout that we have is for typefaces with capital letters only. These faces are often kept in double, triple, or quadruple caps cases.[3] The layout is generally the same as the California case but with the caps section only.

The students experience the case for the first time with map in hand, or at least resting next to the case. Until the student has memorized the lay of the case, he will need to refer to the map when setting type.

Our Type Shop is made up of type cabinets and cases of different sizes and layouts, from donors and printers with different purposes. Because of this, we tell the students to look inside the unlabeled compartments of the cases for unusual or special characters. For example, if the printer who bought the type requested "æ" or "œ" ligatures from the foundry, they will be found there. Sometimes as a space-saving device, more than one type size or typeface is kept in one case. This is acceptable when the size and or face are easily differentiated.

Some of our type is from the home shop of a commercial printer with excellent taste, Mr. John E. Sullivan of Little Pica Press, who stored his type in ⅔ size cases. Some of ours was more recently acquired from a job printer, Mr. A.W. Meers who kept his collection of equipment in three buildings in a gentrifying Chicago neighborhood. He showed his love for letterpress (and cat) by covering the

Single Piece of Type

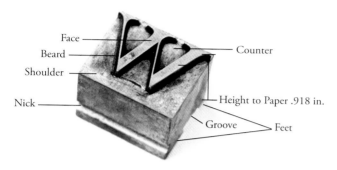

Face — Counter

Beard —

Shoulder —

Nick —

— Height to Paper .918 in.

— Groove — Feet

ffi	fl	5-to-the-em	4-to-the-em		'	k		1	2	3	4	5	6	7	8		$	£			æ	œ	
j					e			i		s		f	g	ff	9		A	B	C	D	E	F	G
?	b	c	d											fi	0								
!								o	y	p	w		,				H	I	K	L	M	N	O
z	l	m	n	h								en quad	em quad										
x				3-to-the-em spaces				a	r			;	:				P	Q	R	S	T	V	W
q	v	u	t									.	-	quads			X	Y	Z	J	U	&	ffl

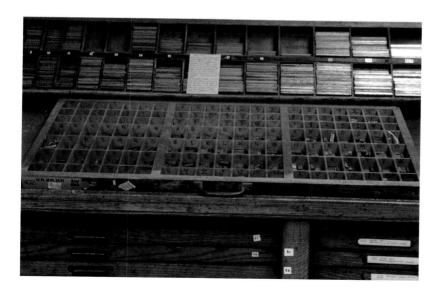

It embodied a mathematical elegance that was not to be, because the most popular pica in use at the time (there were two), put in place by MacKellar Smiths & Jordan Type Foundry, did not correspond exactly to the inch. It was .1660 inch and was named the "Johnson Pica." Mr. Johnson came up with the eponymous pica early on in the foundry's history, and it subsequently came into widespread usage.

Ultimately, the most popular pica, not the best pica, was the one put into use. The marketing power of MacKellar Smiths & Jordan was stronger than that of Marder, Luse & Company. Still, the newly adopted pica was an improvement over the old system. As foundries adopted standardized sizes, types from different manufacturers could be set together in 1879 for the first time with ease.[4]

Mnemonic devices for learning the layout of the California case

b, c, d, e, i, s, f, g
'be careful driving elephants into small ford garages'

l, m, n, h, o, y, p, w ,
'let me now help out your punctuation with commas'

v, u, t, a, r
'villains usually take a ride'[5]

tops of his beautiful oak type cabinets with cardboard to prevent
them from becoming scratched. (And he let his cat sleep on the bed
of the press.)

The type acquired from these two men joined type in our shop
from the Society of Typographic Arts (STA). The STA collected type
and equipment for their members to use. Eventually, in 1984, when
they could no longer keep it in its long-time home of the Newberry
Library basement, it was transferred to the School of Art Institute of
Chicago. This happened mainly through the efforts of STA member
(and SAIC alum) Muriel Underwood. Some of the STA collection
came from RR Donnelley, along with other commercial printers of
the time. The following is from Muriel Underwood's May 1997 arti-
cle about the shop for the *Caxtonian:*

> A 1952 listing of equipment shows that 30 cases of
> Futura were to have come from A-1 Typesetters, four
> cases of Bodoni from Runkle, Thompson, Kovats, and nine
> galleys of Garamond from Poole Brothers. Ludlow Typo-
> graphic Company donated leads and slugs. RR Donnelley
> & Sons Company gave empty California job cases and
> cabinets, an imposing stone, a Vandercook proofing press,
> and other miscellaneous equipment necessary for
> typesetting and printing.[6]

The history of this collection is integral to its spirit. Our goal is to
pass that spirit and history, and the care for it, on to the students. To
aid in their use, the type cabinets and cases of type in our shop are
inventoried, catalogued and cross-listed four ways (alphabetically,
by size, style, and location). They are also shared both in a binder
and digitally. In identifying the type in the inventory by style, the
students slowly learn to distinguish them from each other.

It is important to handle type cases with care. The powerful
force of gravity is explained on the first day of class; it is best to be
aware of it at all times. This may seem like an odd statement, but to
students used to digital type, it is prudent to point it out.

When handling cases, use both hands. Carefully, with each
hand along the sides of the case, pull it incrementally out of the cab-
inet, lift with legs/shoulders to place on top of the slant top cabinet.
If the case is very heavy, get help from a fellow student. We avoid
the method where the case directly below the case in use is pulled
out halfway, in order to support the case directly above, because it
isn't quite as safe. Many of the rails in the old cabinets are wood and
are failing, and therefore cannot support the weight.

For the Love of Letterpress

(Top) Diagram of leading and spacing.

(Bottom left) Dana Packham, *Batman Logo.* Printed with the instruction of Caren Florance, Printmedia & Drawing Workshop, Australian National University, Canberra.

(Bottom right) Audrey Niffenegger, *New Year's Greeting.* Bank Script on Ingres paper with Linoleum Cut, Green Window Studios, Chicago. 1991. (6" x 11⅓".) "This was one of a series of rather morbid New Year's Greetings I made in the 80s and early 90s to send to friends. This was the most ambitious and also the one most often mangled by the US Post Office. The next year everyone received tiny post cards." Photograph by Kenneth Gerleve and Audrey Niffenegger.

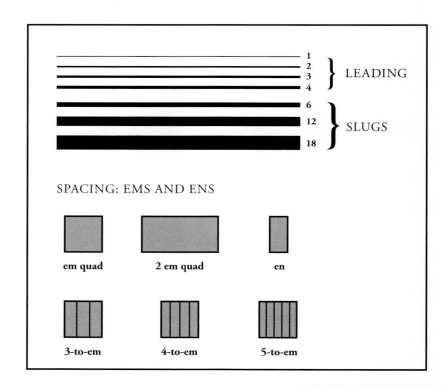

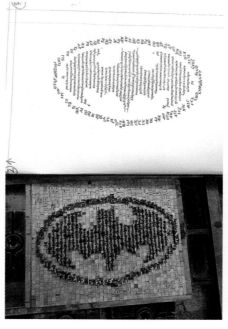

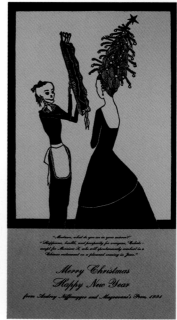

Spacing and Leading

Because they are invisible both in computer typesetting (referred to in Adobe InDesign software as "hidden characters") and in the final printed piece, spacing material and leading are a revelation to students. On the student's first day in the Type Shop, the invisible and hidden becomes visible to them, as solid matter filling the space between words and lines.

Spacing and leading are shorter than type high, which is .918", and therefore they do not print. Each size of type comes with its own matching size of spacing. The basic unit of spacing is the "em quad," sometimes called a "mutton" to distinguish it from its half size relative, the "en quad," or "nut." Quad is short for quadrat, which is larger spacing, usually 1 to 4 ems wide.

A 12 point type requires 12 point spacing, and the em quad of a 12 point type is a 12 point square. Similarly, a 30 point type em quad is a 30 point square. Completing the set are the spaces, 3 to the em (3 of these = 1 em in whatever size you are using), 4 to the em (4 of these = 1 em, ditto) and 5 to the em (5 of these = 1 em). There are also 2 em quads (= 2 em quad) and copper and brass thin spaces. These last two are thin pieces of copper and brass, the copper is ½ point, the brass is 1 point. Copper and brass thin spaces are used for spacing out capital letters and for other very fine adjustments. In the past printers would sometimes cut exceedingly thin sheets of paper down to make even finer spacing adjustments.[7] Often we find these paper thins lingering in our type cases, waiting to be used again by a discriminating student.

For space between words, the California case gives the largest space compartment to the 3 to the em. In many instances this is the most commonly used space between words in ordinary composition. In some shops, however, when closer spacing is desired, the 4 to the em space is the most commonly used.[8] This cuts down on the possibility of unsightly areas of white in a page of text. These areas are called "rivers" when they make vertical lines of white, and "lakes," when they make a visual hole in the text.

Although it is true typographers do not agree on exact standards in spacing some say the ideal space between words in straight matter composition should be about the width of the counter in the lower-case "o."[9] In general, the books of Bruce Rogers are an excellent place to learn about beautiful type setting and spacing; nineteenth century job printing and composition, with its emphasis on speed, are not.

Leading and slugs are pieces of metal placed between lines of type, shorter than type high, to add space between them. The thinnest

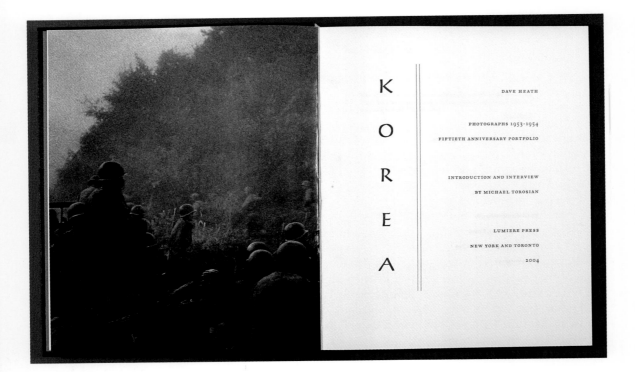

K
O
R
E
A

DAVE HEATH

PHOTOGRAPHS 1953-1954
FIFTIETH ANNIVERSARY PORTFOLIO

INTRODUCTION AND INTERVIEW
BY MICHAEL TOROSIAN

LUMIERE PRESS
NEW YORK AND TORONTO

2004

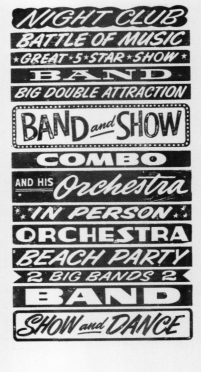

leading is 1 point. There are also 2, 3, and 4 point thicknesses of leading. Leading equal to or thicker than 6 points is called a slug. It can be cut with a slug cutter or lead saw to the desired line length. Leading is usually kept in a leading rack on top of the type cabinet. In our Type Shop we keep 2 point and 6 point slugs in lengths from 6 pica to 30 on hand in the leading rack, while leading longer than 30 picas is stored for use in special projects.

Setting Type by Hand

> *"It would be well for the young compositor, learning how to distribute, to cultivate the habit of promptly picking up every letter he drops on the floor. Type is not improved by walking on it."*[10]

After type and spacing, leading, points and picas have been explained to them, students are ready to set type by hand. We begin with the composing stick. The composing stick is an adjustable hand-held frame for holding lines of type. It is the first tool, after the type itself, required to set type.

The first composing sticks were made of wood and used to set a single line length. The first adjustable stick wasn't invented for another 100 years. In 1645 the first iron composing stick came into use. Before about 1810 all composing sticks were wood or iron, the wood sometimes lined with brass. In 1810, the first steel composing stick was made with a capacity (depth) increased to nearly 2 inches. It marks the line between ancient and modern composing sticks. [11]

Printer's furniture are pieces of wood (often), metal (sometimes) or plastic (rarely) used to hold type in place in the bed of the press while printing. There are substantial differences between wood and metal furniture. Wood furniture is comparatively light and inexpensive. It has give, it expands and contracts with moisture and temperature. With heavy use wood furniture can acquire smashed corners, which reduces its precision even more. Metal (usually iron or steel) furniture is heavy, and can damage the bed of the press if dropped on it.

But metal furniture is comparatively exact in its measurements. Because of this, it is especially useful for locking up multiple pages and close registration. Resalite (plastic) furniture has the advantage of not expanding and contracting, and of lightness. It has the advantages of wood and metal furniture, and none of the drawbacks. It is quite expensive however, and not readily available.

Furniture is stored in a furniture cabinet, with sizes ranging from 2 picas x 10 picas to 10 picas x 60 picas. Furniture, like spacing and leading, is shorter than type high, so does not print. It is cut in

(Top left) Michael Torosian *Korea.* **Printed on Biblio with Linotype Falcon, offset lithography by C.J. Graphics. Design, composition, presswork, and binding by Michael Torosian. Printed in Toronto, edition 200 with a variant edition of 36 including gelatin-silver print. 2004. (9" x 7⅜" x ½".)**

(Bottom far left) Joe Galbreath & Colin Ford, the printing process for *Band and Show, Show and Dance.* **"From Globe Poster Baltimore's hand-cut blocks. Printed without a press, as Globe ceased letterpress printing commercially in the late 1980s. This study in both form and language, recontextualizes the content of these blocks by creating a monumental column of exquisite lettering and disembodied phrases, allowing the viewer to more fully appreciate these workhorses of the twentieth-century American street poster." 2009. (52" x 39".) Photograph by Colin Ford.**

(Bottom left) Joe Galbreath & Colin Ford, *Band and Show, Show and Dance* **block print. 2009. (52" x 39".) Photograph by Colin Ford.**

standard lengths from 10 picas to 15 picas, 20, 25, 30, 40, 50, and 60 picas. Furniture widths are 2, 3, 4, 5, 6, 8, and 10 picas. It is easier for beginners to set their type on a standard furniture size line length, so they will have an easier time arranging the furniture around the type while devising a "lockup" for printing.

In order to correctly set the line length in your composing stick, place a piece of furniture of the desired line length in the stick and close the "knee." Remove the furniture without opening the knee. Holding the composing stick in your left hand, place a slug in the stick of the same length.

The slug should be slightly loose in the stick, not too tight. Listen to the sound of the slug in the stick as you move it back and forth. When the slug is too loose, you hear a different tone than when the slug is snug and not too loose. Try it. You want the tautness of the type and spacing, not the leading, to push slightly against the stick when the line is set.

After you choose your type, be sure to keep a slip of paper in the galley, marked with the typeface name, size, and location. This tactile reminder aids in identification and distribution. Set your first line rag right.

Begin with an em quad, place it close to the knee. Hold it in place with your thumb. Choose the first letter of your text.

Reach into the case with your right hand, find the letter, feel the nick, set it in the stick upside down with the nick up. The letter will read backwards. Then set the second letter and the third until you finish your first word. When you are holding your stick correctly, you will be reading your type upside down, from left to right. Place a piece of spacing material in the stick (for example, 4 to the em) and begin the second word of your text. Continue until you are close to the end of your line. Break your line and fill in with quads and spacing, ending with an em. Always begin and end your line with an em quad. This makes the lines easier to handle, and allows you to hang punctuation.

Use the largest pieces of spacing you can, since too many small pieces of spacing, copper and brass thin spaces make the line springy and difficult to lock up. "Less is more" is a good principle to follow here; if you use the fewest pieces of spacing possible, then you will have fewer pieces to put back in order if the line becomes pied. To correctly fill out the line with spacing, remove smaller spacing and replace them with larger ones. Place larger spacing toward the out-side; smaller spacing toward the type.

Again, whether right or left-handed, you should be holding your composing stick with your left hand and reaching into the case with your right. Feel your line with your right hand. Does it feel

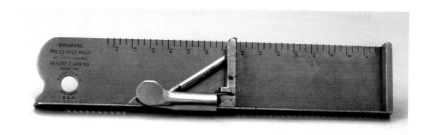

(Top) A composing stick, also known as a job stick.

(Center) Holding the composing stick.

(Bottom) Galley slip.

(Top) Peter and Donna Thomas, *Gypsy Wagon,* Mohawk Superfine Cover. Wood type from the Hamilton Wood Type Museum. 2010. (12" x 9".) Photograph by Peter and Donna Thomas.

(Bottom) Stéphane de Schrevel, *New Year's wishes for 2009.* Six different postcards, manufactured manually from A to Z. "I sent *'nuanced New Year's wishes'* to 96 addressees. The concept of nuance is mirrored in the use of 'regular' and 'bold' characters. Those were arranged in such a way that a half-tone screen effect appeared. When laying out the cards in the correct configuration a big 9 appears." 2008/2009. (4" x 6".) Photograph by Stéphane de Schrevel.

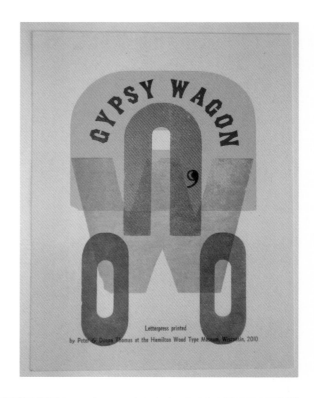

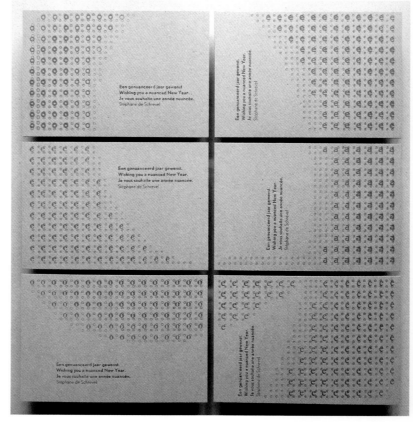

40

tight? Loose? If it feels loose, fill in the line with spacing until it is tight but not too tight. It should stand up on its own without falling over, but you should be able to slide it out of the stick without straining your fingers.

To begin your second line, place a piece of leading of the same line length as the first on top of the line of type. Begin your second line with an em quad just like the first line, but on top of it. Set your text continuing on from your first line. If you are setting 12 point type you should be able to set five lines or so in the stick, after which you can remove them and tie them up in your galley. If your lines are very long and your stick is therefore heavy, transfer your type to the galley after only a few lines. If you have more lines to set in your text, place the first group of lines in the closed side of your galley. Add lines until you are finished and then tie them up together in your galley. (See next section for tying up.)

Wood type is normally too large to set in a composing stick, but it is still a good idea to match your line length with a standard furniture length. Do a trial lockup of the form in a chase or a galley; use reglets and leading for spacing.

When setting a page of type, it is most efficient for all of the lines to be set on the same line length for ease of lockup. Then, when the page is in the bed of the press, all of the lines will form a uniformly taut form. All of the lines must be set with the same degree of tautness. If they are not, some lines will be loose and wobbly while others will be too tight. Both cause the type to be "off its feet". When type is off its feet it is leaning to the side, which causes uneven printing, and sometimes broken type.

Alignment

The way most readers are used to seeing type in newspapers and novels is justified left and right. This isn't the most beautiful way to set type, but some argue it saves the most space. Some prefer rag right (left aligned) for its superior legibility. Like word spacing, there is an ongoing debate about the truth of this. Centered lines of type are also sometimes required. The student must know how to set type all of these ways.

LEFT/RIGHT JUSTIFIED When setting lines left/right justified, begin the line with an em as usual and set your type until you are close to the end of the line. Insert an em. How much space is left? Change 4 to the ems to 3 to the ems to "space out" and fill the line. Do the opposite to "space in." The overall goal is to set a uniform page, avoiding visual holes. When looking at the space between

Measuring Wood Type

Lead type is generally cast in sizes up to 72 point, (although M & H in San Francisco sells one typeface in 84 point) after which the amount of metal needed for each character generally becomes too much and the accumulated weight of a set page too heavy. Wood type is manufactured for type sizes above 72 point. While foundry type is measured in points, wood type is measured in lines or picas.

1 inch = 6 pica = 6 lines

1 pica = 12 points

72 points = 1 inch

letters, keep in mind their shapes; strive for visual balance. Do not use en spaces or spaces smaller than 5 to the em between words. Hyphenate words to create a pleasingly spaced page. "Spacing in" is preferred over "spacing out."

RAG RIGHT After justified setting, you can easily set rag (text that is left-aligned). When setting rag right, keep the same word space throughout, and break the lines to create a pleasing "rag" while avoiding "widows" or "orphans." A widow is one word on a line by itself at the end of a paragraph. An orphan is a short line or one word appearing at the top of a page or column. While setting type, look at the edge created; an undulating line is preferred over one very long line followed by one very short line. Make adjustments until you have a satisfactory "rag" edge.

CENTERED In order to set a line of centered type, place an equal amount of spacing material before the first word in the line and after the last word in the line. The shapes of letters can cause the line to look "off-kilter" even if mathematically correct. Adjust as needed with spacing material. Again, use the largest spacing material possible.

FLUSH RIGHT To set flush right, rag left, first set the line as you would rag right. When approaching the end of the line (where you plan to break it) slide type in the stick to the end of the line and fill out the beginning of the line with spacing and quads.

HANGING PUNCTUATION "Hanging" quotes and other punctuation into the margin creates an aesthetically pleasing visual line. To hang punctuation in justified copy, remove the em quad from the end of the line with the quote marks (quote marks are the most common marks to hang) and replace with an en and a 4 to the em. Adjust as needed.

CHOOSING LINE LENGTH Take into consideration the length of the text, size of type, and standard furniture size. One rule of thumb is to not exceed the length of 1.5 lower case alphabet in the size and style of the type used.[12]

"If you have liberty to choose, never set a solid text type in a measure of more than fifty ems of that text type. Long lines are hard to read."[13] Therefore, do not set 12 point type on a line longer than 60 picas. To aid in readability, if the line length is longer, increase the leading.

QUADDING OUT When you fill up the line with spacing, you are quadding out. Consider using leading to fill up space if you are short on quads. For example, two 6 point slugs of the correct length can fill up space in a line with 12 point type. Measure the length of the space to be filled and select or trim to the appropriate length of leading. Place the smallest space next to the letter or punctuation, the largest on the end of the line. For uniformity of tautness from line to line, never loosen the knee of the composing stick to remove the type.

Finally, before justifying, read and correct your line, and when justifying, do not force characters and spaces into the line. For tips on acquiring speed in hand setting, see the ITU book *Lessons in Printing*.[14] Although the simple mechanics of setting type by hand can be learned in an afternoon, to do it really well and quickly takes years of practice.

Tying Up the Form

When your composing stick is full, you are ready to transfer your type to a galley. Do not unclamp the knee. Place your thumbs and first fingers against the ends of the line. Exert firm pressure. Angle or lean it out while squeezing. Avoid lifting the type if possible. Walk the type out carefully, sliding it onto the corner of the closed end of the galley. Add additional lines until your form is finished.[15]

TYING UP Cut off approximately 36 inches of string from a cone or reuse pieces from previous forms. You need enough to wrap around your form three times, and to wrap some onto your fingers.

1. Anchor string by wrapping it around your three middle left hand fingers several times.

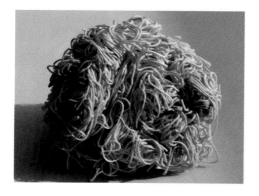

(Left) Recycled string.

2. Place your anchored string fingers on the corner of the form away from the corner of the galley.

3. Wrap with other hand clockwise, returning to the corner with your anchored fingers.

4. As you turn the corner while wrapping your string, be sure to go below the starting corner, which will catch the string and hold it in place. Tighten the string at the same time.

5. Go around the form three times, tightening and catching the string each time at the same corner.

6. On the third time, again tighten and catch the string on the corner, then stop and tuck string under with a short piece of leading. Pull knot to corner. This allows the string to be untied easily when in the bed of the press.

If the knot is tied incorrectly, the form could pi or spill when the string is loosened for lockup. After dressing the form (surrounding the type with furniture in the bed of the press), attempting to untie inappropriate knots is an unnecessary frustration.

Ink

William Morris made his own ink especially for his books. He was able to achieve rich black printing with it, in emulation of the dense blacks of medieval manuscripts, which was an aesthetic long out of favor. Gutenberg, amazingly, is still our best model for a rich black ink.

Today there are many different manufacturers of ink, although few of them make ink especially for letterpress. Good letterpress ink is stiff in body and highly pigmented. The ink must sit on the face of the letter and transfer easily to the paper, producing a sharp opaque print.

Offset lithography inks are often too runny and not as densely pigmented as letterpress inks. Traditional lithography inks are mostly too stiff for letterpress. Etching inks are unsuitable because of their runny, oily nature, which allows it to sink into etched lines and be wiped off the surface of a copper plate, the opposite of what is desired for letterpress ink.

"It took six months to remove the paint from my 1994 Nissan Sentra Limited Edition. Working in sections, I reduced each piece to bare metal with a hand-held electric sander before painting it gray. As I sanded the car, the layers of paint were reduced to dust. I saved as much of the dust as possible. When the process was complete, I sifted the pink paint dust into a fine powder and then mixed it with oil to produce ink. The 'Limited Edition' emblem from the back of the car was enlarged and turned into a plate for letterpress printing. During printing I used all of the gritty, viscous ink; my dust collection yielded a 'Limited Edition' of 243 prints. Due to the imperfect nature of the production methods involved, each print is completely unique. A car is a tool, a device that saves time and work for its owner. With a finite number of days to accomplish our life's goals, things like automobiles allow us to move toward these ends most efficiently. The process of removing paint and collecting dust from my car was an attempt to explore the economy of time and the pursuit of goals. It was arguably a superfluous and cumbersome way to accomplish something (itself, arguably worthless) that could have been done far more quickly and easily, not unlike modern-day use of letterpress printing as an artistic form."
—*Eric Baskauskas*

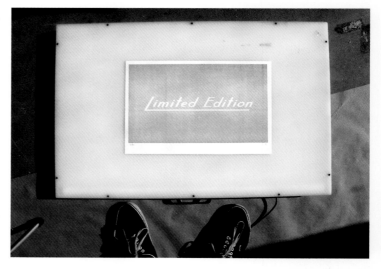

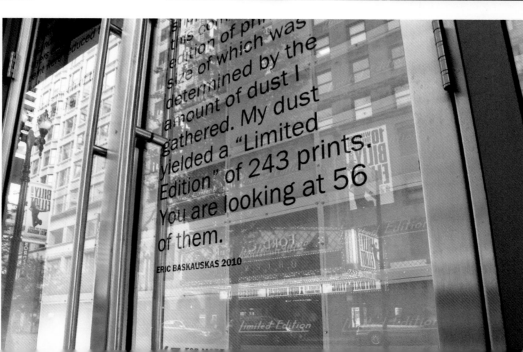

Fritz Klinke of NA Graphics, the owner of the original Vandercook blueprints, sells ink especially for letterpress made by Victory Ink, and by Great Western Ink. Van Son Ink has been making letterpress ink since 1872. Their rubber base ink has additives that slow the ink drying time and reduce washup.

Oil based letterpress ink (somewhat of a misnomer since rubber base is also oil base) is also used. It doesn't have additives to slow the drying process, and is often more densely pigmented than rubber base ink. It can start to dry on the press, however, which then requires additional washup.

To remove the ink from the can, skim the knife over the surface of the ink to remove it. Never dig in the can with the knife; keep the surface flat. Digging exposes the ink's surface to air, which dries it out.

Depending upon the paper, letterpress ink dries by oxidation, absorption, and/or evaporation. When letterpress was the primary method of commercial printing, a different formula of ink was used for each kind of paper. For example, "news ink" was a thin, free-flowing ink which "set" only by absorption into the paper; "bond ink" was a fast-setting ink for bond, ledger or other hard finish paper which allowed for very little absorption into the paper.[16]

(Top left) Eric Baskauskas, *Limited Edition*. **Ink made from car paint dust and burnt plate oil #3. Photograph by Eric Baskauskas.**

(Center left) Eric Baskauskas, *Limited Edition*. **Printed from polymer plates on 100 lb French white Recycled Construction cover stock. 2010. (12 ½" x 19".) Photograph by Eric Baskauskas.**

(Bottom left) Eric Baskauskas, *Limited Edition*. **Pop-Up Art Loop installation on view at 33 West Randolph Street, Chicago. 2010. Photograph by Eric Baskauskas.**

Paper for Proofing

We will discuss paper in depth in Chapter 4. But briefly, use smooth white paper for proofing. Scrap bond/computer paper will work. Carbon paper can also be used as a "quick and dirty" proof, bypassing the need for ink. You need a galley for the type to be at the correct height in order to proof on a galley press.

Note: adjust packing on proof press as needed. A kiss impression (one where the impression in the paper is barely detectable) is the most desirable to detect broken and wrong letters in the proofing stage.

Proofing

For proofing on a galley proof press, tie up your form and place it in the corner of the galley. Check to be sure no string or any other object is under the type. Place two magnets, one on each side of the form, to hold the form firmly against the corner of the galley. Alternately, place your form in center of the galley, surround it with four slugs, then four magnets.

Use a planer to set the type on its feet. Before inking, place the planer flat on top of the type, tap gently on it with the quoin key.

Always use black ink and white paper when proofing. The purpose of the proof is to find broken or wrong letters; black ink on white paper provides the strongest contrast and makes the type the most visible. Use a brayer to roll out the ink on an ink slab. Roll the brayer over the type several times in different directions. Do not use too much ink. Do not push down too hard with the brayer; this will ink the shoulders of the type and produce an over-inked print.

Place the paper carefully on the type. Without shifting the paper, take the handle of the press and roll the cylinder over type and paper, taking the proof. Lift the paper straight up from the type.

The first sight of a proof from type set by their own hands can cause the beginner's eyes to widen, as they experience the delayed "instant gratification" the proof gives. Even if the first proof is not perfection, it conveys a humanity a laser print from a digital file

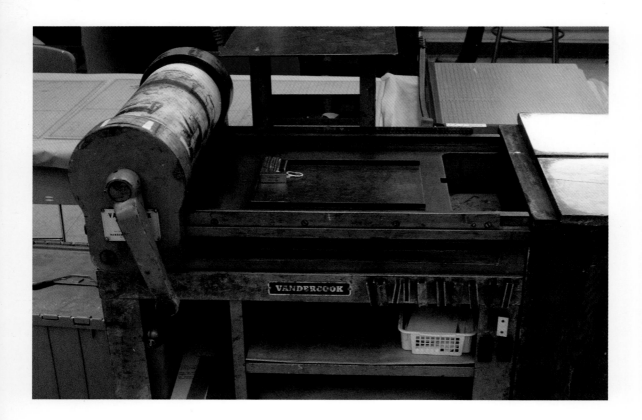

For the Love of Letterpress

doesn't. In the words of recent letterpress beginner, now SAIC letterpress teaching assistant, Kelly Harris:

> Above my desk at home pinned to the wall I have the very first letterpress endeavor I set by hand; a 1 x 3 inch paper that states simply (in the ever prophetic words of Yoda): *"Do* or *do not.* There is no *try."* Not only is this "piece" printed on cheap white computer paper; it's torn crooked, the printing is obscenely non-uniform, and there's a very conspicuous thumbprint on the back side. Arguably, it's an exercise or draft [...] But to me, these qualities are what appeal to me the most—that these mistakes are so tactile—that their existence is possible only through a physical human presence (or in this case, error)—*that* is what I find most invigorating about working with type.

(Bottom) Students in the SAIC Type Shop, looking at their first printed sheet. 2012. Photograph by Amara Hark-Weber.

(Top) Chloe Brown, *A Good Pair of Socks*. Hand embroidered, original text, mixed type, handmade box, edition of 2. "My work explores personal experiences and nostalgia, focusing on aspects of family relationships. *A Good Pair of Socks* is an attempt at recreating existing memories and to express a longing for the past. The closeness that I share with the process of letterpress, feels to be an extension of the closeness I have to the story told." 2011. (8³⁄₁₆" x 6¼" x 3⅞".)

(Bottom) Lead Graffiti: Raymond Nichols/Jill Cypher/Tray Nichols, *All preservation is merely…* Hand-rolled background copper ink onto American Masters stock and over-printed with hand set antique wood type. 2008. (22" x 15".)

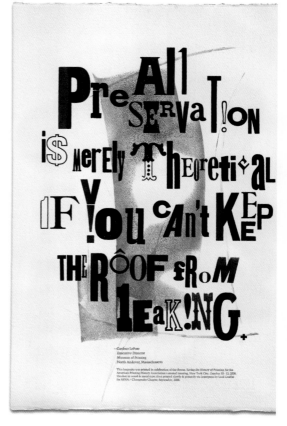

Notes

1 David Bolton, "Empty California Job Case," The Alembic Press website. Available at: www.alembicpress.co.uk/Alembicprs/CALBLNK.HTM (Last updated 15 April 2009; last accessed July 25, 2012.)

2 In fact, Graham Moss of Incline Press in Oldham, England has done so for his own shop. Yet Mr. Moss is greatly in the minority. David Bolton, "Incline Press Improved Double Case," The Alembic Press website: www.alembicpress.co.uk/Typecases/IPDCASE.HTM (Last updated 3 March 2009; last accessed July 25, 2012.)

3 Ralph W. Polk and Edwin Polk, *The Practice of Printing Letterpress and Offset,* Seventh Edition (Illinois: Chas. A. Bennett Co., Inc., 1971), 29.

4 Richard L. Hopkins, *The Origin of the American Point System for Printers' Type Measurement* (West Virginia: Hill & Dale Private Press, 1989), 27.

5 Glen U. Cleeton and Charles W. Pitkin, *General Printing: An Illustrated Guide to Letterpress Printing,* revised by Raymond L. Cornwell (Illinois: McKnight & McKnight Publishing Company, reissued California: Liber Apertus Press, 2006), 23.

6 Muriel Underwood, "For the Love of Letterpress, a Tradition Continues in Chicago" *Caxtonian,* (May 1997). Available at: www.caxtonclub.org/reading/loveoflpress.htm (Last accessed July 26, 2012.)

7 "For non-distribution systems (in which machine composition is used and the metal melted and recast), the ½ point spaces are paper, while the 1 point thickness is cut from manila tagboard or 1 point strip metal spacing." Ralph and Edwin Polk, *The Practice of Printing,* 33–34.

8 Ralph and Edwin Polk, *The Practice of Printing,* 46.

9 Cleeton and Pitkin, *General Printing,* 29.

10 *Unit 1, Lesson 5. International Typographic Union (ITU). Lessons in Printing, compiled into Student's Manual, ITU Course of Lessons in Printing* (Indiana: Bureau of Education, International Typographical Union, 1934), 26.

11 "First History Ever Written of Composing-Sticks From the First to the Last and Best, 1450–1914," Star Tool Manufacturing Company, Springfield, Ohio. *The American Printer* (New York: Oswald Publishing Co., Volume 60, No. 1, March 1915), 91.

12 Ralph and Edwin Polk, *The Practice of Printing,* 195.

13 Theodore L. DeVinne, *Manual of Printing Office Practice* reprinted from the original edition of 1883 with an introductory note by Douglas C. McMurtrie (New York: Battery Park Book Company 1978), 19.

14 International Typographic Union, *Lessons in Printing. Unit 1, Lesson 5,* 18.

15 Cleeton and Pitkin, *General Printing,* 52–3.

16 Ralph and Edwin Polk, *The Practice of Printing,* 129–30.

CHAPTER FOUR *Press and Printing*

Gutenberg printed on paper and vellum. His paper was made from cotton rags, surviving the 500 years since, forever sealing the relationship between sublime printing and rag paper. Handmade paper, luscious, soft, able to take on many colors, custom-made, thick, pleasingly human is the top choice for many letterpress printers, just as it was for Gutenberg.

Paper

Commercial paper today, used for large runs of magazines, books and newspapers, is made from trees. After the tree is de-barked and chipped, it needs to be chemically treated in order for it to be made into paper. To get away from this process, seen as environmentally unfriendly, alternatives to paper made from trees have been sought.

"Tree-free" paper can mean paper made from cotton, bamboo, or hemp. Although cotton paper is certainly "tree-free" it is also seen by some as non-sustainable because of the large amount of resources, such as water and pesticides, used when growing it.[1] Bamboo is touted by growers and paper manufacturers as a better alternative.[2]

Bamboo paper for letterpress has come onto the consumer market in the last four years and is offered by paper mills such as Legion in the U.S., Lana Papiers in France, Hahnemuhle in Germany, and Awagami in Japan. For so many manufacturers to come out with paper made from bamboo indicates a demand for an environmentally sustainable letterpress paper. However, bamboo is classified as an invasive plant in some places. We may yet find the most eco-friendly solution doesn't involve shipping a raw material halfway across the world.

Letterpress has the ability to accept many different materials for printing, especially if photopolymer plates are used. These plastic plates made from digital files tend to be much more resilient than lead type, which is especially true when a heavier punch is used. The best paper for letterpress is soft and smooth, with minimal sizing. Handmade paper fulfills these criteria easily. It is the best choice for letterpress as well as the most expensive. The next best choice is mouldmade paper, made on a machine from rags or cotton linters. Least expensive is machine made paper from wood pulp. Between these three options there are many different possibilities.

The grain of paper is evident in machine made and mould-made paper. Handmade paper has no grain, because the grain of the paper is created when the majority of the fibers line up parallel to each other in manufacturing. This happens when the paper pulp is poured onto the moving mould and the fibers line up, like logs

(Left) *A Noble Fragment, Being a Leaf from the Gutenberg Bible, 1450–1455.* **Courtesy of Chicago Public Library, Special Collections.**

(Top right) Tara Bryan,
Down the Rabbit Hole.
Wrapper printed on Thai
Bamboo paper. 2005 (6" x 6"
x 1".) Photograph by
Ned Pratt.

(Top far right) Robert
Howsare, *1'00"* Letterpress
printed 16 mm single per-
forated clear leader, Eiki
NT-0 Projector. Printed
using polymer plates and
48 point type. 2012. Each
film is an edition of 10. (24"
x 36".) Photograph by
Robert Howsare.

(Bottom right) Vandercook
Press.

floating down a river.[3] In the formation of handmade paper, the fibers behave more like leaves in a pond, floating freely in all directions, and so do not form a grain.

The effect of grain is that the paper wants to bend, fold, and tear much more easily in one direction, with the grain, rather than the other, against the grain. For this reason, the grain of the paper should always be parallel to the spine of the book, so the pages will bend and fold in harmony with the turn of the page.

The two sides of the sheet are different for most paper. One side is the rough mould side. The other side is the smooth felt side, which is normally the top side. Take note of the position of the watermark if there is one. When the watermark is right reading, this is the front or top of the sheet. In some papers the difference between the mould and the felt side is much more pronounced, some it is less.

Wash your hands before you cut or tear the paper to size. Use a paper knife or a tear bar for a soft edge. Employ a guillotine or a paper cutter for a sharp edge. Stack the paper printing side up. Traditionally, the deckles are at the bottom or the right side of the sheet. This works well for feeding on a Vandercook, since it is better to feed paper into the grippers from a uniform cut edge, rather than an irregular deckle. Be sure to tear to size some newsprint for proofing as well.

Allow for setup and spoilage. One rule of thumb is to expect 10–20% spoilage. When printing an edition of ten, consider buying half as much more of the edition paper. Expect some spoilage in each step. In the printing of each color, every time the paper goes through the press, and in the binding. A student's biggest expense is paper, buy as much as you can possibly afford.

The Vandercook Proof Press: "The Editioning Press"

Originally, Vandercook presses were not made to be used the way we use them: to teach art students who are almost always absolute beginners. The presses, manufactured in Chicago beginning in 1909, were originally designed for accurately checking the printability of type and plates.[4] Vandercooks are capable of producing very high quality printing even when the operator knows comparatively little about the process.

We refer to our four Vandercooks that have grippers and adjustable inking systems as "Editioning Presses." This is to distinguish them from our small gripperless Vandercook No. 1 that has to be

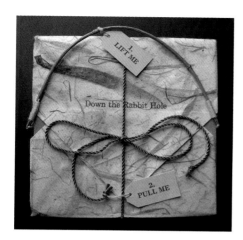

inked with a hand brayer. We named them for the way the majority of Vandercooks still in existence today are used: for editioning.

> Vandercook without a doubt is the most recognized name in the world for proof presses…The first press was a "rocker" proof press, made with a geared cylinder. Up to the development of this press all proofs were either made on a roller press that depended on gravity for impression or on a Washington Hand Press.[5]

We have five Vandercooks: a Universal 1, a Universal 1AB, a No. 4, and a No. 3. The fifth Vandercook is a No. 1, a small galley press without grippers. After the students set type by hand, print proofs on the No. 1, and make their corrections, we print the type together in a broadside on one of the editioning Vandercooks.

Before you begin on any press, wipe down the bed and bearers with a slightly oily rag. Refer to the press manual for oiling and lubrication instructions. Be sure all moving parts are oiled. (In the SAIC Shop staff oversee this task to be sure every student is not oiling the presses in our Shop.) Buy a manual from NA Graphics, or check the list of manuals, downloadable from the Boxcar Press website.

PACKING The goal of packing is the perfect impression. Too much packing and your "punch," or impression, will be too strong, possibly damaging the type and press. Too little and the ink won't fully transfer to the paper. At one time the "perfect" impression was a "kiss" impression; no indentation in the paper was visible or felt. Our contemporary aesthetic is an impression just distinguishable on the back of the paper, and just visible on the front. This differentiates letterpress from the flat printing of lithography and digital printing.

In our Shop we use oiled tympan paper for packing. Follow the recommended thickness for your press: read the cylinder undercut stamped on the cylinder of the press. When the carriage is at the feed board, the numbers are visible stamped on the operator's side. The Universal 1 has a cylinder undercut of .040".

Keep in mind the .040" thickness recommended by the manufacturer is measured from the bare cylinder to type high, which includes the paper on which you are printing. So if you are printing on very thick paper, you must reduce the thickness of the packing by removing sheets; add packing when printing on very thin paper. Measure the total thickness with a micrometer.

Oiled tympan paper becomes compressed with use: be sure to change it periodically. Some printers, such as Claire van Vliet,[6] use a Mylar draw sheet in place of, or on top of oiled tympan paper. Two

For the Love of Letterpress

of the advantages of Mylar are that it is easily cleaned off when it gets ink on it, and it doesn't need to be changed often. Follow the directions in your press manual when changing the packing:

> Repacking Cylinder. The cylinder is ground for .040" packing. It is very important the correct amount of packing is carried on the cylinder. Incorrect packing is apt to cause misregister, slurs, and wrinkles. Overpacking will cause the cylinder to print longer than the form and under packing, shorter. The cylinder packing plus the sheet to be printed should be from .002" to .003" over the cylinder bearers. This can be checked with a straight edge. For most work the best cylinder packing consists of all hard manila sheets. Thickness of packing may be adjusted by placing thin sheets next to the cylinder.
>
> To change or adjust packing, move cylinder to center of bed (on trip if there is a form or plate on the bed) so the reel rod is in the up position. Unlatch reel rod ratchet with wrench provided and loosen drawsheet from reel. With left hand, grasp packing and as cylinder is returned to feed board, lay packing on feed board. If necessary to change the drawsheet, loosen the fillister head screws in the packing clamp gripper bar. Unless overlays are being used, only the drawsheet is held by the bar. When moving cylinder to center of bed to secure packing, hold packing in position by smoothing it out with left hand. Be sure packing is tight to cylinder at both sides of gripper edge.[7]

MIXING INK COLORS In our Shop, students mainly mix ink for short runs, using the color wheel, or the Pantone swatch book as a guide. The Pantone book is manufactured for offset printers, but it can be used for choosing letterpress colors. It is handy for finding out what base inks are needed to mix a particular color. For example, you can't achieve certain colors if you don't begin with reflex blue or process yellow.

Offset printers use an ink scale to measure out amounts of ink for mixing colors. The Pantone book's ink mixing proportions assume the printer has one. If you don't have an ink scale, you are still mixing by eye, but with a useful guide (the percentages) and a goal (the printed swatch). If you need to mix a special color consistently, be sure to mix a sufficient quantity. Or, order the ink already mixed from your ink supplier.

Using the Pantone Uncoated Formula Guide, look at the percentage indicated next to your chosen color. As the NA Graphics website states: "The basic color chart for mixing PMS colors for

(Top far left) Wesley Kloss, *Autophobia*. Posted on a mailbox. Printed in two editions: 75 on white and 75 on red. French Paper: Aged Newsprint 80 lbs, Red Construction 80 lbs. Each poster is numbered and all distributed posters have a corresponding location to edition number, which is cataloged in a printed book. 2010. (19" x 12½".) Photograph by Wesley Kloss.

(Top left) Wesley Kloss, *Autophobia*. Posted on a door. 2010. (19" x 12½".) Photograph by Wesley Kloss.

(Bottom left) Wesley Kloss, *Autophobia*. Posted in a Laundromat. 2010. (19" x 12½".) Photograph by Wesley Kloss.

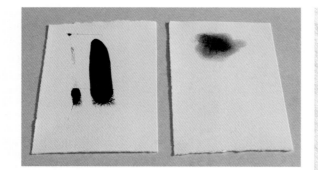

ALL·THE Danish policemen pass the DAY AT HOME in bed.

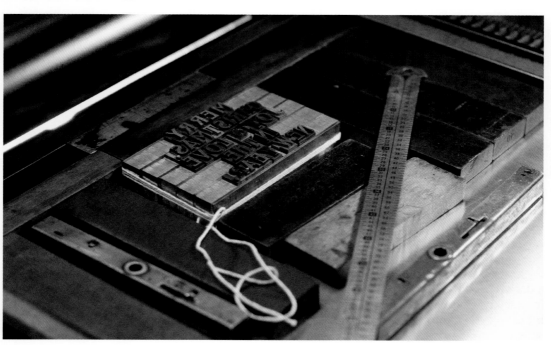

printing—note these are printed by offset and letterpress typically lays down a much thicker layer of ink than offset. PMS colors printed letterpress typically print darker than […] the Pantone sample books will show."[8]

Some printers compensate for this difference by using opaque white instead of transparent white. Others will use transparent white as the PMS book directs, but will aim for one shade lighter than the chosen swatch. Opaque white tends to be more blue-white and is a good choice if you do not want the paper to show through, or want the color to cover something else. Transparent white is a vehicle with no pigment in it, but has a yellowish hue because of the oils in it. It spreads out any pigment it is added to, giving it a watery look, and allows the paper and any other printing underneath to show through.

The authors of *The Practice of Printing* advise: "Start with the lightest color first, then add other colors sparingly. If the lighter color should be added last, it would take much more ink to secure the proper proportions, and would result in an over-supply of the mixture."[9] Pigment amount and density is much greater in inks other than white. Therefore, you will create much more ink than you need and waste white ink if you do not follow this rule.

Another guide for mixing ink is the color wheel. Explore hues and tints by mixing a color with black or white. Complementary colors can be added to a pure color to reduce brightness or to darken value. "There are times when a dark ink other than black may be used for subduing colors …Violet, for instance will deepen yellow and not turn it green as a blue-black is very apt to do."[10]

To make an inking slab to mix your ink, place white paper on a flat, comfortable height work surface, then place a thick piece of glass with finished edges on top. Tape down the edges. The area for mixing ink should be clean and well lit, with natural light if at all possible. Remove ink from the can, skimming the surface with an ink knife. Scrape the ink onto the inking slab and work it. Pick out any dried bits of ink with the knife. Check the consistency of the ink. Drip the ink from the knife to the slab. It should flow slowly down. When in a pile on the slab, it should slump a little, not result in a flat puddle. If the ink is too thick, work it with the knife to loosen it. Add a small drop of reducing oil to loosen it further. If the ink is too thin, add magnesium carbonate.

Color perception is subjective. The ambient light in which you are looking at a color affects it greatly. Test your ink color by making a draw down or a tap out. For a draw down, take a clean, flat-edge inking knife and dip the corner into the mixed ink. Dot the small bit of ink onto your piece of paper. With the flat edge of the knife, scrape the ink down the sheet, first pressing hard at an 80-degree

(Top far left) A "Draw Down" and a "Tap Out."

(Center far left) The cylinder undercut is found on the side bearing.

(Top left) Michael Caine, Casey Sorrow, and Christopher Rowlatt for Ithys Press, Dublin. Detail from *The Cats of Copenhagen* by James Joyce. 2012. (28" x 38" x 2".) Photography by David Monahan.

(Bottom left) A good lockup is essential to good printing.

angle and then changing to a 45-degree angle. This is in order to evaluate the result of both a thin film of ink and a thick one. Make your draw down on your actual printing paper to see how the paper color affects the ink color.

For a tap out, dip a clean index finger into the mixed ink. Tap your slightly inky finger on the paper, creating a dense area of ink. Continue tapping until you have a less dense area of ink as well. Evaluate the result; compare to the Pantone swatch, make corrections to the mixed ink if necessary. If you have ink left over, wrap it in aluminum foil folding the packet tightly. Attach your draw down and mixing guide as a label.

To add ink to the rollers, add a small amount at a time. Using the inking knife, take a small amount of ink and dab it in even 'dots' across the rider roller. Begin with less ink than you think you need. It is easier to add more ink than to take it away. Turn on the motor until the ink is evenly distributed across all of the rollers.

ADJUSTING THE ROLLER HEIGHT After adding ink to the rollers, use the correct roller gauge for your press to check your form rollers are the correct height. In our case it is a .918" roller height gauge. It is best to do this with no type in the bed.

With the rollers in Print position, push the gauge under each inked roller in turn and look at the resulting ink stripe. The ink stripe should be about the thickness of a nickel (the manual specifies $1/16$" to $3/32$".)

Check the front and back rollers, far side, and operator's side. Turn the four black roller adjustment knobs, (Universal 1) or loosen the 2 set screws and turn the 4 large flat screws (No. 4 and No. 3) to raise and lower the rollers: clockwise to raise, counter clockwise to lower. Repeat until the roller height is correct at all four points. For the 4 and 3, after setting the roller height, tighten both set screws.

Lockup

Pica ruler in hand, begin the lockup.

The principles of a good lockup are:

1. The fewest pieces of furniture are used.

2. Stable construction.

3. The quoins are not over-tightened, causing the type and furniture to rise.

4. The form remains immobile, with no workups.

To determine the placement of type in the bed, place a sheet of proof paper cut to the correct size into the grippers from the top edge. Measure in picas from the top edge of the sheet to where your type will begin. To allow for the grippers, subtract two to three picas (depending on the press). If type or plates is placed in the way of the grippers, they will be smashed.

POSITIONING PAPER AND TYPE The puzzle of the lockup is fun. Enjoy it, use math, don't rush.

If you have a computer printout of your design or a complete proof on the same size paper as the edition, measure in picas the distance of your type from the edge of the paper. With these measurements, you can place your type in the bed of the press correctly and quickly. If possible, lock up the form in the center of the press bed. You will fill in the entire bed with furniture; it adds stability to the form and aids in registration.

You cannot print a bleed on the edge of the sheet where the grippers hold the paper. If a bleed is required, position it away from the grippers, or cut the sheet down after printing.

Place your type in the bed with the same amount of space you measured on your proof from type to top edge. If you are feeding from the top of your sheet, the top of your first line of type will be toward the left in the bed of the press—as you face the bed from the operator's side.

> **Example:** if there are 6 picas from the position of your type to the top of your sheet, place a 4 pica width piece of furniture there. To center the lines of the broadside left/right, allow space (about 4 picas) for quoins (metal wedges for tightening the form) on the operator's side; and fill up the near and far sides of the form with an equal measure of furniture.

At the feed board, measure from the cylinder side bearing to the sheet. Measure from the bearings on the sides of the press bed to calculate the placement of the form. The two measurements align. Move the side guide to gain the correct position, or move the form in the press bed.

In the furniture cabinet, each piece fits in its own slot, many marked on the end with the length. Add and subtract the standard sizes in order to complete your lockup in an efficient manner. For stability, the furniture should be arranged around the form like a frame, not like bricks in a wall.

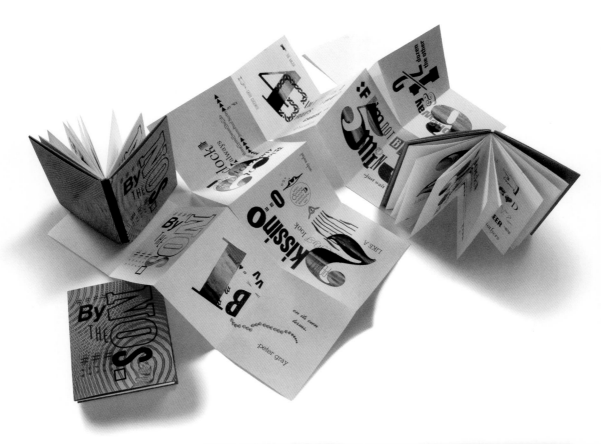

(Top) Lead Graffiti, *By the Nos.* Caterpillar book printed from handset wood and metal type on Mohawk Superfine. 2012. (5" x 4" x 1".) This book is the result of a full-day 'creative' letterpress workshop with design students. Photograph by Lead Graffiti.

(Bottom) Lead Graffiti, *By the Nos.* Lockup. Photograph by Lead Graffiti.

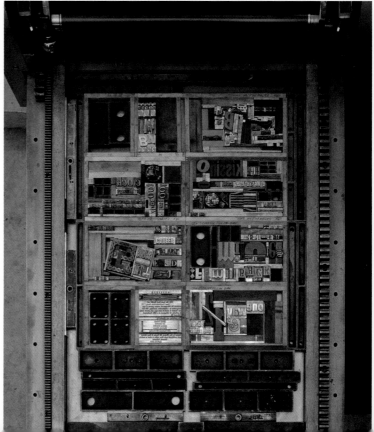

As you face the bed, the quoins are always placed on the side closest to the press operator, and on the right. When the quoins are tightened, they push away from you and toward the head dead bar. Deviation from this rule results in poor lockup and impossible registration.

Once the form is loosely dressed, with furniture arranged around it, untie it. Keep the string in the galley if you want to use it again. The lockup can now be completed by filling in gaps with furniture or reglets and tightening the quoins.

QUOINS A quoin is a small metal wedge that expands when tightened, tightening, or locking up the form. There are many different designs for quoins. One consists of a pair of triangular wedges of metal that are pushed apart with a matching quoin key. A second kind is the Challenge "hi-speed" quoin. It is rectangular and expands evenly when the matching quoin key is used. When teaching beginners, the advantage of the wedge-shaped quoins is the obvious mechanics of the design. On the high-speed quoins, the mechanical innards are covered up.

To tighten the quoins, use the matched quoin key. Turn the key only to finger tight; too much will cause the form to rise up and result in inconsistent printing. Plane your type to set it on its feet before tightening the quoins. Do not plane type when it is inked. Place the planer on its side when not in use, so bits of debris do not stick to its face and subsequently cause damage to it or type.

Press Operation

Keep safety in mind at all times when printing. Tie back long hair, and remove any long necklaces or jewelry. The Vandercook Universal 1 and No. 4 have motor-driven ink drums that can catch dangling items.

Place your sheet of paper on the feedboard and step on the gripper pedal. If you are printing on the Vandercook No. 3, which has no gripper pedal, advance the cylinder until you hear a click, then bring the cylinder most of the way back to the feedboard. As you do so, the grippers will open. Feed your paper before the grippers close. Use two of the paper guides (next to the grippers), and the side guide. The paper guides are adjustable. Turn the knobs attached to the paper guides to adjust them. For the side guide, loosen the knob to move it; tighten it in position.

INKING, TRIP/PRINT Be sure the bed of the press is free from any obstruction (i.e. random type, string, wrench, pica ruler). Turn the handle with your right hand and arm while holding the paper

lightly with your left hand against the cylinder. As you turn the handle, step toward the end of the bed; follow the paper with your left hand. Release the paper as it passes over the type.

As the carriage reaches the end of the bed, you will hear a "click" and a "clack" when the grippers release the paper. As you hear the sound, take your printed sheet out of the grippers and place it on the feedboard. In addition to the sound of the grippers releasing, you will hear the sound of the automatic trip mechanism. Holding the handle of the press, turn and walk back to the feed board. As you do so, the press will be in Trip mode (inking only), and will not print on the tympan.

MORE ON TRIP/PRINT When in forward motion, the carriage of the press will be in "Print" mode, unless the operator overrides that function by flipping the Trip/Print knob to "Trip." If this override is not used, then once the gripper pedal is depressed, the carriage will be in Print when in forward motion, and when returning to the feed board, it will be in Trip. In Trip the cylinder is actually in a raised position and therefore does not print; in Print the cylinder lowers, bringing the type in contact with the paper.

If you accidentally print on the tympan, wipe the ink off with a rag and a small amount of odorless mineral spirits. Rub the area with baby powder (or magnesium carbonate) to prevent the ink from transferring to the back of your edition paper.

Checking the Impression

Evaluate your first proof by looking at it with a loupe. When the rollers are too low, ink is pushed into the counters of the letters and an outline appears. When the rollers are too high, some letters or parts of letters are not inked at all. If the ink looks blurry around the letter instead of sharp, the type is over-inked. If you see a partially printed letter, check for type off its feet, broken type, or under-inking.

If there is slurring on the proof, check the lockup to be sure type and form are held firmly in place. Slurs are blurred impressions caused by the sliding of the paper on the printing surface. Check packing; it may be too much.

Read over your copy again for spelling errors; have a "fresh eye"—a fellow student—look it over. Check the back of the sheet for impression/punch. Feel it. Run your fingers lightly across the indentation. A slight indentation is desirable; too much impression damages the type. Add or remove packing sheets as required.

Generally, if both sides of the sheet will carry printing, less impression is desired. If only one side will be printed on, more impression is tolerated.

Makeready

"Makeready" is preparing the form to print evenly. When they were new, Vandercook presses were advertised as requiring no make-ready; the claim was made with the understanding the printer was using new type and plates, all type high. In practice, some areas of the form may require more ink than others. For example, make-ready is necessary if a cut below .918" is being printed at the same time as type.

As an example, consider a paragraph of 10 point type composed with a two-line drop cap. The amount of ink deposit ideal for the 10 point type will likely not be enough for the two-line drop cap. With makeready, the impression for the drop cap can be increased by adding a thin tissue to the spot where the drop cap comes in contact with the tympan. Now, more of the ink from the drop cap will transfer to the paper.

The opposite practice can be applied if more of the form requires less ink or punch on only a small area. In that case, cut out the area on the tympan requiring less punch. Another method of makeready, called underlay, brings an area below type high up to height by placing tissue underneath. Just be sure the added height does not raise the area above .918".

Registering Multiple Colors

Set all the type together in one form. Take a proof; finalize the placement. Then print on a piece of tracing paper cut to the size of your edition paper.

Remove from the form only the type that is *not* part of the first color run. Fill the resulting gap with furniture. Print another proof. Lay the tracing paper proof over the proof to be certain your type is still in the same position. Make a sketch of the lockup if multiple runs (or different print sessions) are required. Be sure to write down the exact measurements of the furniture as well as any reglets or leads used.

Editioning

An edition is a set of books or prints that are all exactly the same. The ability to make multiple copies is one of the great joys of letterpress printing, and traditionally, one of its goals.

When editioning, always handle your paper with care. Use clean hands. Do not allow stray ink or fingerprints in the margins.

Be aware of the back of the sheet, keep it just as clean as the front, using a pink pearl eraser or an X-acto knife to remove stray marks.

Once you have the press set up, take a proof on your edition paper. Examine the impression and adjust as needed. When the print is exactly as you want it, mark it and keep this print to compare all subsequent prints.

Irregular inking sometimes occurs when editioning. To avoid it, compare your "approved" proof to each print or page as you print. Always check for any broken letters or "workups." Squint your eyes to see if the overall "color" of the text block is the same. Do not add too much ink as you print. One extra trip between each print is recommended, especially for a large form.

After Printing: Cleaning the Press

When you are finished with your printing session, turn on your ventilation system or open a window. Clean off your type with a rag and solvent. Use the type brush if needed to remove excess ink. Do not allow ink on type or cuts to dry. Make a sketch of your lockup if you plan on using it again. Be sure to write down the measurements of the furniture, reglets and any other leading used. Return furniture to its proper place in the cabinet, tie up type, and return to galley. Distribute your type.

Clean the press with vegetable shortening followed by odorless mineral spirits. In our Shop, we subscribe to a rag service that picks up the soiled rags, cleans them, and brings them back. Finish off with a final wipe-down with solvent and a white rag to be sure all of the ink has been cleaned. Check for stray ink on the press bed and on the bearers. Leave the press as clean as you would like to find it.

Platen Presses (Chandler & Price)

Chandler & Price presses (C&Ps) were originally used for job printing, and are driven by a foot treadle. In the late nineteenth century, Harrison T. Chandler, an Illinois banker, while negotiating to buy an interest in the Cleveland Type Foundry, met William H. Price, son of a builder of printing presses. They founded the Chandler & Price Co. of Cleveland to build printing equipment. In 1884 the partners introduced their famous jobber. They sold their presses competitively until the early 1960s when the tremendous growth of offset duplicating, plus competition from two other press manufacturers, Kluge and the Heidelberg, eventually doomed all models of the C&P.[11]

In our Shop, we have two non-motorized Chandler & Price presses: an 8 x 12 and a 10 x 15. Intermediate or advanced students can learn to print on them, but beginners do not. They can be dan-

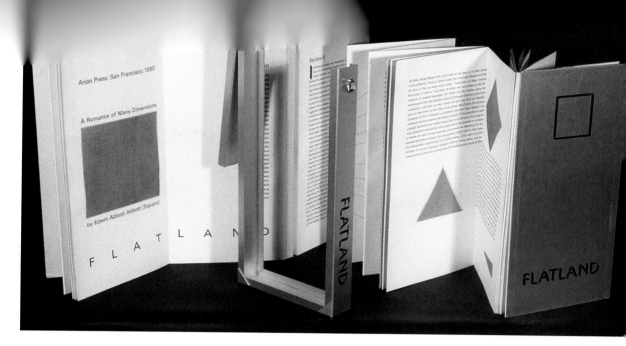

(Top) *Flatland* by Edwin Abbott. Arion Press. Accordion-fold of 56 folded panels, with an introduction by Ray Bradbury, and illustrated with fourteen line drawings and ten diecuts by Andrew Hoyem. Watercolors added by hand. Univers, composed in Monotype, then reset by hand. T.H. Saunders hot-press paper. Bound in aluminum covers, in a hinged and clasped aluminum container. 1980. (14" x 7" x 1½".)

(Bottom) Russell Maret, *Specimens of Diverse Characters.* Letterpress and Intaglio on a custom making of Velke Losiny paper using digital and foundry typefaces designed by Russell Maret. Type and images printed from photopolymer plates, except for Iohann Titling, Nicolas, and Lisbon Ornaments, which were cut and cast in new foundry metal by Micah Currier at the Dale Guild Type Foundry. 2011. (16½" x 11¼" x 1¼".) Photograph by Annie Schlechter.

gerous for beginners if used carelessly. When operated with safety in mind, however, the C&P is appropriate for printing cards, invitations or small posters, and books. Motorized C&Ps are often used for longer runs.

The C&P, and platen presses in general, accommodate stiffer paper stock since the paper does not need to conform to a cylinder. Chipboard is a favorite on this press, as well as coasters and business cards. The platen press is also good for embossing titles on book cloth-covered boards. For specific operating instructions of a C&P, we recommend *Elementary Platen Presswork* by Ralph W. Polk and *Platen Press Operation* by George J. Mills.

The coordination of eyes, hands, and feet necessary to operate a C&P efficiently demands considerable practice. When mastered, the rhythmic union of printer and press is a delight to behold.

Notes

1 "Cotton is considered the world's 'dirtiest' crop due to its heavy use of insecticides, the most hazardous pesticide to human and animal health. Cotton covers 2.5% of the world's cultivated land yet uses 16% of the world's insecticides, more than any other single major crop." Environmental Justice Foundation, 'The deadly chemicals in cotton.' (Environmental Justice Foundation in collaboration with Pesticide Action Network, London, UK: 2007.)

2 "[…] bamboo stands out as one of the most renewable resources available." Legion Paper website. Available at: www.legionpaper.com/legion-bamboo/ (Last accessed July 25, 2012.) "Made with an mix of 80% bamboo and 20% recycled kozo (mulberry) Awagami's BAMBOO papers represent the finest eco-alternative archival papers for fine artist everywhere." Awagami Paper Press Release. www.prlog.org/11782175-awagami-japan-expands-their-fine-art-bamboo-paper-collection.html (Last accessed January 25, 2012.)

3 ITU, *Lessons in Printing,* Job Unit IV-Lesson 6 (Bureau of Education International Typographical Union, Indianapolis Indiana: 1938), 17.

4 "Although the Vandercook is usually thought of as a proof press it is much more. Designed as an engraver's test press, it is a hand/power operated cylinder press with power driven ink distribution and designed in every detail as a precision tool for test proving both single and multicolor plates. […] [It is] a testing instrument for accurately checking the printability of type and plates." Fred Williams, 'The 'Vandy'! A Splendid Press.' *Type & Press* (Issue No. 67, Winter 1991). Available at: vandercookpress.info/downloads/articles/T&P%20articles/t&p-williams.pdf (Last accessed July 25, 2012.)

5 Harold E. Sterne, 'A Short History of Vandercook.' Available at: vandercook-press.info/articles.html (Last accessed July 25, 2012.)

6 'The Gourmet Vandercook: Printing on a Press Never Really Designed for Printing,' *The Devil's Artisan, A Journal of the Printing Arts,* 17, 1985. Available at: devilsartisan.ca/pdf/DA17.pdf (Last accessed July 25, 2012.)

7 *Vandercook Manual: Operation–Maintenance, Parts List No. 4.* Vandercook and Sons Inc. (Chicago, IL). n. d.

8 NA Graphics website. Available at: order.nagraph.com/ink.html (Last accessed July 25, 2012.)

9 Ralph W. Polk and Edwin Polk, *The Practice of Printing.* Seventh edition (Peoria, Illinois: A. Bennett Co. Inc. 1971), 132.

10 Fred W. Hock, *A Handbook for Pressmen* (Fred W. Hoch Associates, Inc., NY: 1939), 149.

11 Fred Williams, 'C & P—Pressman's Favorite,' *Type & Press,* Summer 1977. Courtesy of the Amalgamated Printers' Association. Available at: www.apa-letterpress.com/T%20.../Chandler%20&%20Price.html (Last accessed July 25, 2012.)

In relief printing, ink is laid on the high parts of a surface; the lower areas are not inked. The surface of the relief matrix must be flat, with the highest parts of the surface type high (.918"), in order to receive consistent inking from the rollers. The only relief matrix we have discussed thus far is metal type set by hand. There are other ways to set type however, and other relief matrices.

Foundry Type

Foundry type is made of lead, tin, antimony and sometimes copper,[1] and is the hardest of the cast types. Gutenberg and early printers cast their own type by hand, one letter at a time with a hand mold. Once type foundries became a separate industry in the sixteenth century,[2] they grew larger and more consolidated, finally collapsing under their own bureaucracy. The invention of Linotype in 1886 and Monotype in 1896 hastened their decline.[3]

Today, some foundry type can still be purchased new from The Dale Guild Type Foundry or second hand, cast by one of the many now defunct type foundries. For a heartbreaking tale of the last days of the great type founders conglomerate, American Type Founders, read *The Fall of ATF: A Serio-Comedic Tragedy* by Theo Rehak.

Foundry type is the main kind of type we work with in our Type Shop. We are actively using the vestiges of the main foundries of Chicago and beyond: Barnhart Brothers & Spindler, Marder Luse & Co., and Western Type Foundry among them.

We do our best to care for our foundry type, emphasizing to our students its relative fragility, as well as the difficulty (in some cases, the impossibility) of replacing it.

Monotype

There are two machines needed for Monotype casting: a keyboard and a caster. The keyboard records the text as holes in a roll of paper, and the caster reads the roll of paper, not unlike a player piano, casting the type. In this way an entire book can be set.[4] The type is cast in order by machine, producing individual types set in lines, superseding the need for hand setting.

Monotype was originally designed to be printed once (hence the name), and then melted down for re-casting. For this reason, its metal composition is softer than foundry type, which can be set, distributed, and re-set many times. But Monotype machines can also cast type durable enough for hand setting, which can then be distributed into a case, re-set and printed multiple times.

(Left) Flowers and Fleurons, *The Shipping Forecast.* **Four sheets of Somerset Velvet printed letterpress with original Gill Sans wood type. 2010. (82" x 14".) Photograph by Flowers and Fleurons.**

(Top) Muriel Underwood, *The Type Louse* (title page). A long-neglected tale from *Chicago Industrial Folklore.* Set in 8/11 Linotype Century Schoolbook by Leonard Creswell, Line Typesetting Co. 2000. (3 ½" x 2 ¾".)

(Center) Muriel Underwood *The Type Louse* (spread).

(Bottom) Kelsey Keaton, *The Maere.* A research-based project with a letterpress book and ephemera created from found material. 2011. Photograph by Kelsey Keaton.

(Right) Western Type Foundry em quad.

74

Monotype spaces are not standard spaces. If re-spacing is required, throw the Monotype spacing into the Hell Box (a box for holding broken or damaged type) and replace it with the appropriate standard spacing material. Some printers who don't trust the machine spacing even "run it through the stick"—treat the type like foundry type and set each line with standard spacing in the composing stick.

Linotype

Linotype was invented by Ottmar Mergenthaler, and first introduced in 1886 at the *New York Tribune.* Born in Germany in 1854, Mergenthaler emigrated to the U.S. in 1872, and obtained his first patent at age 20.[5] Linotype, and its close competitor the **Intertype,** which appeared in 1913, are cast on a single line (line-o'-type) after the copy is typed into the machine from a keyboard.[6] If an error is found in the line the entire line must be re-cast. From the point of view of the printer, aside from the type designs, there is little difference between Linotype and Intertype. They are each a single machine with a keyboard, above which, molten lead is poured into type matrices, simultaneously casting the type and spacing the line. The solid lines are then assembled into a type form, which, after being printed, can be melted down again. Mergenthaler reportedly got the idea for the brass matrices that would serve as molds for the letters from wooden molds for making "Springerle," which are German Christmas cookies.[7] Linotype is still available today.

Ludlow

A Ludlow is a type-casting machine that produces slugs from lines of assembled matrices. The matrices are kept in cases and set by hand in a special stick. Since the product of the Ludlow caster is a solid slug, the type is always new. Once printed, the slug is melted down and the matrices are distributed. One of its most prominent advantages is its space-saving attribute. It was originally developed for display composition, and is capable of producing letters up to 144 point, and figures up to 240 points. More usually its type faces range from 6–48 points.[8]

Wood Type

In 1834, William Leavenworth and A.R. Gillmore adapted the pantograph, a mechanism for copying draftsmen's drawings, by combining it with Wells' lateral router.

(Top right) Sherwin Beach Press, *Saving His Life*. Written by Lee Sandlin. Illustrated with family photos from the collection of Nina Sandlin. "Sandlin tells the story of the extraordinary life and bewildering illness of his father-in-law, Russian immigrant Nick Cherniavsky." Letterpress and photo-etching, designed and printed by Martha Chiplis on Twinrocker Taupe using Monotype Ehrhardt set by Michael Bixler. Binding designed and executed by Trisha Hammer. 2008. (9 ½" x 11" x 2".) Photograph by Jack Kraig.

(Center right) Sherwin Beach Press, *Saving His Life*. "A map of Nick's lifetime of travel, drawn by Deborah Reade, serves as the front endpaper." Photograph by Jack Kraig.

(Bottom right) David Wolske, *(un)touch(ed)*. Printed on Legion Paper Drawing Bristol; Typeface: CNC router-cut Vista Sans wood type. Other materials: type-high brass rule. 2012. (24" x 17¼".) Photograph by David Wolske.

(Bottom far right) David Wolske, sketch for *(un) touch(ed)*. Photograph by David Wolske.

The combination of the router and the pantograph allowed for the mass mechanical production of wood type…The combined router/pantograph produced wood type well into the decline and closing of the industry in the late twentieth century.[9]

Author and collector Rob Roy Kelly on Wood Type:

> With their multitude of inventive and imaginative forms and designs, they were expressive of their makers and of the people and spirit of the period. They were used prolifically, announcing ship sailings and auctions, serving for land notices, wanted posters, theatre handbills. Even today their power to evoke an image is evident.[10]

J. Edward Hamilton founded the original Hamilton factory, called J.E. Hamilton Holly Wood Type Company, in 1880, and within 20 years became the largest manufacturer of wood type in the United States,[11] The plant was well situated for wood type manufacturing, as it was built at the crux of two rivers. The waterway could bring logs downstream from the forests of Wisconsin, and Lake Michigan, giving excellent access to ships from further afield. Hamilton eventually branched out into printers' cabinets, then gas dryers, then medical furniture, but continued to make wood type until about 1985.[12]

After years of declining interest, printers are again acquiring and using wood type, driving prices up. Even individual letters are desirable to non-printers for decorative purposes. These can be priced so high as to make buying enough to print a poster cost-prohibitive. There are also people venturing into making their own "wood type" from wood and other materials.

We have in our Shop a very limited amount of wood type, a bit of Gothic, Egyptian, and Black Letter. To challenge our students and give them a reason to print with the wood type we have, we encourage them to choose from the largest, which is 5", and integrate it as an abstract shape into their books. When they do so, they begin to examine both positive and negative areas of each character and their relationship to the page format.

Images

Almost since print began, lettering, then type, has been combined with images. Before printing, the images were the letters, pictograms and hieroglyphics. As writing developed and the alphabet

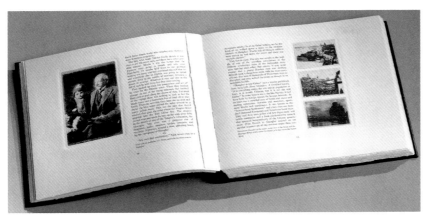

became abstract and separate from images, humans began to utilize the expressive power of each. The methods to create and print the images have evolved over time, but the human desire to communicate, and to do so beautifully, has remained constant.

Ornaments

Metal-flowers were the first ornaments used in printed books to be set at the head of the first page and the tail of the last page…[13] We can use these "ivy leaves" or "flowers" properly, only by remembering that typographic ornament must harmonize in line and treatment with its accompanying letter-press…Before making a choice of "flowers," it is a good plan to study the specimen-books of Caslon, Fry, Fournier, Didot, and Bodoni, which will reveal many good designs and give hints for employing what might otherwise seem useless material.[14]

Printers' ornaments have gone in out of favor in typography, just as ornament has in architecture and art. For example, writing in the 1920s, printer and historian Daniel Berkeley Updike had a fondness for it,[15] but poet and typographer Robert Bringhurst, writing in 1996, seemed to prefer ornaments not used at all.[16] Contemporary artists and printers use ornaments constructively for image-making. However, embracing ornaments doesn't have to be a denial of modernism. Like architect Louis Sullivan's ornamentation, clean lines can form their underlying structure.[17]

Woodcuts

Woodcuts existed before moveable type. The earliest dated woodcut is the *Diamond Sutra,* a printed book with both text and image. It is a Buddhist text, written in Chinese, and dated AD 868.[18] And in the West, "Among the first surviving records of European wood-block printing is a fragment of a block depicting a Crucifixion. This block (…) has been dated about 1380, and since it is too large for the paper produced at that time, was probably intended for printing on cloth."[19] The fragment is carved on both sides, and includes carved uncial letters as well.

Woodcuts are created by cutting on the cross grain of the wood. The wood grain is visually present as one of its main characteristics. The cutting tools, called gouges, are various kinds of sharp knives, v- or u-shaped. Gouges can cut away parts of the wood, leaving only the raised portions to print. The wood typically employed is pine

(Top far left) Stacey Stern, *'Typeface' Poster for Chicago Premier.* Digitally designed and printed with polymer plates. A limited edition was printed on test prints printed at the Hamilton Wood Type Museum with wood type made by them. Created for the Chicago premiere screening of 'Typeface' a documentary on the Wood Type Museum. "I like to marry…the digital realm of the twenty-first century and the nineteenth century printing era." 2010. (12½" x 19".) Photograph by Kimberly Postma.

(Top left) Stacey Stern, *'Typeface' Poster for Chicago Premier.* Digitally designed and printed with polymer plates. 2010. (12½" x 19".) Photograph by Kimberly Postma.

(Bottom far left) Scott Fisk, *This Way.* Hand set wood and metal type. 2012. (21" x 9½".) Photograph by Scott Fisk.

(Bottom left) Tracy Honn, Silver Buckle Press, *IO (II).* Van Lanen and Van Lanen Streamer wood type printed on Somerset. "It's thrilling to get to work with a twenty-first century wood type…Matthew Carter is interested in the ways his Van Lanen types can be manipulated on press to produce visual surprises…I composed forms I could print, work and turn, shift and overprint to create patterns exploiting the Latin type design…" 2011. (12½" x 7½".)

post \post\ n 1 : a piece (as of timber or
metal) fixed firmly in an upright position esp.
as a stay or support : PILLAR, COLUMN
vt 1 : to affix to a usual place (as a wall) for
public notices: PLACARD n 1 : relay station,
courier vi 1: to travel with post-horses adv:
with post-horses: EXPRESS n 1 a : the place
at which a soldier is stationed vt 1 b : to
station in a given place prefix 1 a : after :
subsequent : later b : behind : posterior :
following after
script \skript\ n 1 a : something written:
TEXT b : an original or principal instrument
or document c (1): MANUSCRIPT (2) : the
written text of a stage play, screenplay, or
broadcast 2 a : printed lettering resembling
handwritten lettering b : written characters:
HANDWRITING 3 : a plan of action
post·script \'po(s)-skript\ fr. post + scribere
to write : n : a note or series of notes ap-
pended to a completed letter, article, or book.

and basswood. Artists who practice Ukiyo-e, the Japanese woodcut technique using water-based ink, prefer wild cherry which is fine grained and hard.[20]

Artists who make their own woodcuts will want to consider the living organic presence of the wood. To see the grain better, try inking up the blank block before drawing or cutting on it, in order to utilize it in your composition. Keep in mind that both sides of the wood can be carved.

Wood Engraving

In 1770, Thomas Bewick in England began the revival of woodcuts by developing the technique of using a special engraving tool for cutting on the endgrain of the wood instead of the crossgrain.[21] The tools for wood engraving, as it was called, are burins and gravers. Wood engraving, made popular for the mass market by newspapers because of its natural affinity with type, became widespread in the 1800s.[22]

Since they are cut on the endgrain, wood engravings have a crispness and delicacy of line, allowing them to harmonize well with type. The wood is most often boxwood or, although slightly less desirable, maple.[23] Wood engravings tend to be smaller than woodcuts because of the smaller girth (as opposed to the length of the planks cut from the tree, as in woodcuts) of the trees favored, and the larger amount of work involved in preparing the blocks for cutting and printing.[24]

Those who make wood engravings today have the choice of non-wood materials as well. Resingrave is a synthetic medium invented by Richard Woodman in Redwood City, California that approximates the qualities of boxwood for engraving.[25] Artist and wood engraver Barry Moser has used it extensively for his work.

Linoleum

Although linoleum was invented in the early 1860s, it was first used for printing only in 1890 in Germany for the manufacture of wallpaper…The earliest linoleum cut, or linocut, is dated 1903 by Erich Heckel, the first major artist to adopt the medium. He and the other artists of the artist's association Die Brücke regularly used linocut through the next dozen years. It was subsequently used by Picasso and Matisse to great effect.[26]

Linoleum is "made with powdered cork, rosin, and linseed oil, with a burlap backing."[27] It is available mounted type high, and has

(Top left) Paul Brown, *Ten.* Bembo and wood borders from the collection of Hamilton Wood Type Museum on Arches. 2009. (19" x 13".) Photograph by Kevin Montague.

(Bottom far left) Roni Gross, *PS.* Printed on Bockingford paper using wood type and polymer plates. 2011. (10⅞" x 12".) Photograph by Jordan Provost.

(Bottom left) Cabaret Typographie with Officina Typo, *Typo Game Poster.* Printed with Fregio Mecano, a modular wood typeface designed and made in Italy in the 1920s. 2011. (20" x 27".) Photograph by Cabaret Typographie.

(Top right) Cliché Letterpress Studio, *Cliché Christmas Card.* Savoy Bright White 220lb 100% cotton paper. 2011. (7" x 5".) Photograph by Cliché Letterpress Studio.

(Top far right) Cliché Letterpress Studio, *Cliché Christmas Card* (detail). Photograph by Cliché Letterpress Studio.

(Center) Jessica Spring, *Ingrained.* Printed by Jessica Spring. Composed with hand set ornaments, Engravers Bold, wood type, and wood rule then letterpress-printed on handmade Western red cedar and abaca paper. The prints were bound into a vintage cedar shake sales display, replacing the original panels. A one-of-a-kind work focusing on community, expressed through the text that compares trees and forests to people and the connections they can build together. 2011. (12" x 20" x 3".) Photograph by Richard Nicol.

(Bottom right) Jessica Spring, *Ingrained* (detail). Photograph by Richard Nicol.

(Bottom far right) Elizabeth Fraser, *Hello Mr Caslon.* Emoticons made from lead sorts printed on Somerset Velvet with Caslon type. 2010. (6¼" x 8".) Photograph by Elizabeth Fraser.

no obvious grain. It can be cut the same way as wood, with the same cutting tools. When cutting linoleum, remember, just as in type, the image is reversed when printed. Many artists find it easier to cut curves in linoleum than wood.

Drawings can be transferred to the surface of the wood or linoleum and cut out. Alternatively, there is the direct method. Draw on the wood or linoleum with ink or pencil and interpret the drawing as you cut it out. Print flats of color with uncut blocks. Heat the linoleum with an iron to make it easier to cut.

Plates: Magnesium, Zinc, Copper, Photopolymer

When photography was invented in 1839, it led to the development of photomechanical processes used for printing[28] such as photoengravings which are plates, mounted type high, for printing halftones and line drawings. Halftones, which appeared first in New York in 1880,[29] consist of a system of different sized dots that print one color, but cumulatively make up a tonal scale. Photoengravings are made from "original images such as drawings, paintings, photographs, and letter forms, which are converted into relief printing image carriers (plates)."[30]

Metal printing plates can also be ordered unmounted, and then raised up by the printer either with wood, or with a mounting system (such as a honeycomb base and toggle system).[31]

Copper, and **magnesium** are the two common photoengraving metals. **Zinc** was formerly among them until environmental laws forced most engravers to abandon it.[32] Zinc was for line engravings and coarser halftone screen engravings. Copper, which is harder than zinc, is the most expensive and is for the highest quality work. Magnesium, which has largely taken the place of zinc, is harder than zinc, but not as hard as copper.[33]

Owosso Graphics, one of the largest manufacturers of letterpress plates, states on their website, "Magnesium can yield cost savings, and is often best used on smaller areas with smoother papers, while copper is typically beneficial for larger areas, more heavily textured papers, and extra long runs."[34] Royal Graphix, another Midwest engraver, has been an excellent, dependable source for magnesium letterpress plates for our Shop for more than 25 years.

You don't need a computer to order a plate, just mail a line drawing to the platemaker, and they will turn it into a plate. Copper plates cost more and last longer; magnesium can corrode over time if not stored correctly. To store magnesium plates for longer periods, spray a light film of oil on the face and place in a plastic bag.

НОВОГОДНИЕ ПОЗДРАВЛЕНИЯ
ОТ МАСТЕРСКОЙ ВЫСОКОЙ ПЕЧАТИ «CLICHÉ»

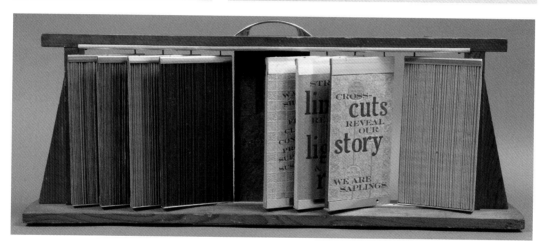

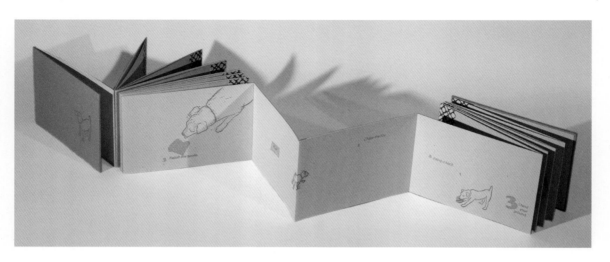

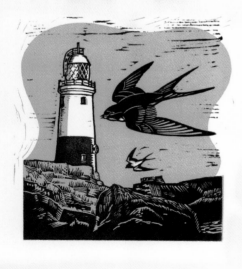

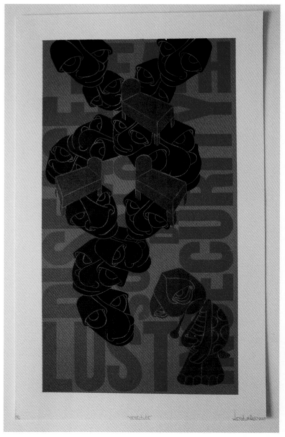

Photopolymer is the newest material for letterpress plates. A photosensitive plastic, it can be washed out with water after exposure. Some printers invest in their own photopolymer platemaking machines, so are able to control their own platemaking. An all-in-one platemaker can be bought for $7,000 to $10,000 new. It contains an exposure unit, a wash out unit and a drying unit. If you have one of these, you only need to purchase the electricity to run it, the unexposed photopolymer material, and negatives, and you are in business.

Photopolymer plates, like everything printed letterpress, must be brought up to type high. Normally, a metal base accomplishes this task. There are several competing brands. Three of them are: Bunting, PatMag, and Boxcar. All are aluminum or steel, two are magnetic (Bunting and PatMag). More bases modeled after the Boxcar Base entered the market recently. The Boxcar Press website is a good source of information.[35]

After processing, photopolymer plates work very much like magnesium or copper. With its shallower depth (the distance between the printing face to low part of the plate) photopolymer is less forgiving of uneven or too-low rollers, and of overinking.

Two of the main differences between metal plates and photopolymer plates are: (1) Metal plates will keep for a long time if stored correctly; photopolymer is not meant to be kept, (2) Metal plates can be ordered already mounted; photopolymer comes unmounted.

To learn more about photopolymer, the definitive text (since 1998) is considered to be Gerald Lange's book, *Printing Digital Type On The Hand-operated Flatbed Cylinder Press*.

Laser Cut Materials

Laser cut materials are a natural extension of woodcuts carved by hand, and of type manufactured with a pantograph. Students who are already familiar with the computer software find it an easy switch to using the laser cutter made available to them at SAIC. Other students who are more familiar with the wood shop utilize the equipment there, such as routers.

SAIC's laser cutters have been a real advantage for those students who are interested in type design, or in printing from large type (which we don't have much of) and for those who want to save money. In fact, in some instances it is less expensive to laser cut an image in Masonite than it is to order a photopolymer plate, once you add in negatives and the shipping costs.[36]

(Top left) Ashley Hairston, *The Daily Routine of the Addy-Dog.* Letterpress on Canson Mi-Teintes paper, French Paper Speckletone and patterned paper. 2009. (4" x 6" x ¾".)

(Bottom far left) Helen Ingham, *Now Cometh The Spring.* Woodletter (two color DeLittle Art Sans) and two color linocut. 2012. (16 ½" x 11 ½".) Photograph by Helen Ingham.

(Bottom left) Will Sturgis, *Destitute.* Wood type and linoleum blocks on Arches paper. Inspired by the book *The Moon and Sixpence* written by Somerset Maugham, loosely based on the life of painter Paul Gauguin. 2003. (19" x 11 ½".) Photograph by Elena Bazini.

(Top right) Alessandro Zanella, *Ecce Video*. Poems by Valerio Magrelli. Eight linocuts by Lucio Passerini. Set with digital type Legacy Sans. Title page and poem's titles set in Monitor typeface designed by Alessandro Zanella. Printed on Tyvek® from photopolymer plates in black. Bound at the press by Alessandro Zanella. Accordion binding with Tyvek® and black heavy paper. Flexible cover with linocuts printed on front and back; enclosed in a transparent plexiglass case 2006. (13" x 8⅔".) Photograph by Alessandro Zanella.

(Center right) Bethany Armstrong, *Giant Anteater*. Letterpress printed from laser cut Masonite at The School of the Art Institute of Chicago. 2009. Photograph by Bethany Armstrong.

(Bottom right) Bethany Armstrong, *Foundry Alphabet Proof Print*. Letterpress printed from laser-cut Masonite at The School of the Art Institute of Chicago. 2009. Photograph by Bethany Armstrong.

(Bottom far right) Russell Maret, *Specimens of Diverse Characters*. The deluxe copy of the book with a form of newly cast foundry type designed by Maret and cast by The Dale Guild, housed in a clamshell box. 2011. (16½" x 11¼" x 1¼".) Photograph by Annie Schlechter.

Whether new or old, all of these relief matrices can be combined. Although now there are far fewer type foundries casting many different typefaces in metal, there is surviving casting equipment. There are people who are proficient with it, and want to teach others. Photopolymer allows us to print digital type on old presses. Perhaps, in the future, laser cut photopolymer will become more commonly used, or 3D printers will have the ability to "cast" type more economically.

But here, in the present, is The Dale Guild Type Foundry, who, in possession of matrices from ATF as well as engraving and casting machines, ingeniously combines digital with analog technologies. The Dale Guild can create new matrices for newly designed type and cast it in lead; giving us renewed hope that this technology will survive, far into the future.

Notes

1 Theo Rehak, *Practical Typecasting* (Delaware: Oak Knoll Books, 1993), 60.

2 Frederick G. Kilgour, *Evolution of the Book* (Oxford: Oxford University Press, 1998), 92.

3 Kilgour, *Evolution of the Book*, 116.

4 Ralph W. Polk and Edwin Polk, *The Practice of Printing*. Seventh Edition (Peoria, Illinois: Chas. A. Bennett Co. Inc. 1971), 145.

5 http://www.zionbaltimore.org/history_people_mergenthaler.htm (Last accessed September 28, 2012.)

6 Kilgour, *Evolution of the Book*, 113, 116.

7 Margaret Genovese, "Presstime, Mergenthaler's Marvelous Machine Turns 100 This Year," American Newspaper Publishers Association, Newspaper Association of America, v. 8, nos. 1–6, p 16. 1986. Available at: http://books.google.com/books?id=GbEgAQAAMAAJ

8 Victor Strauss, *The Printing Industry: An Introduction to its Many Branches, Processes, and Products* (Publisher Printing Industries of America, Washington DC, in association with R.R. Bowker Co., NY 1967), 90–91.

9 http://www.utexas.edu/cofa/rrk/endcut.php (Last accessed July 6, 2012.)

10 http://www.rit.edu/~w-rkelly/html/05_obs/obs_wood2.html (Last accessed August 6, 2012.)

11 http://woodtype.org/about/history (Last accessed November 26, 2012.)

12 http://www.utexas.edu/cofa/rrk/manufacturers.php (Last accessed September 28, 2012.)

13 Daniel Berkeley Updike, *Printing Types Their History Forms and Use: A Study in Survivals* (MA: Cambridge Harvard University Press 1923), 238–239.

14 Updike, *Printing Types*, 241.

15 Updike, *Printing Types*. Fournier le jeune's *Modeles des Caracteres*, 1771 showed "ingenious and charming" ornamental arrangements, 252.

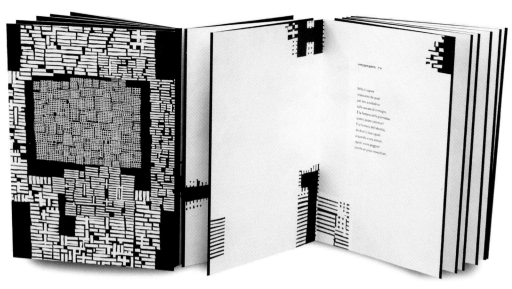

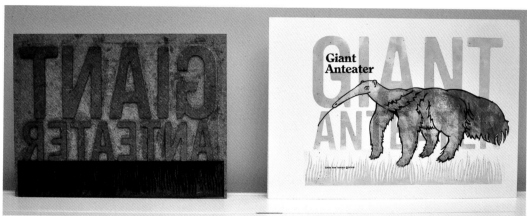

Giant
Anteater

ABCDEEFGHIJ
KLMNOoPQ
RSTUVW
XYZ
FOUNDRY

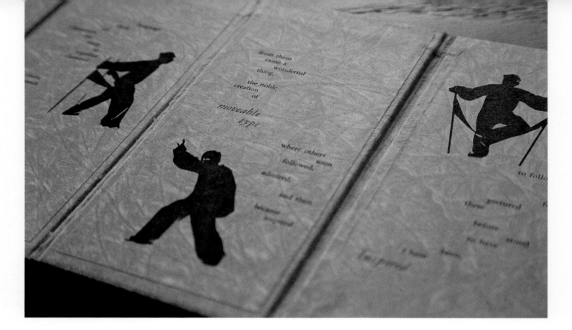

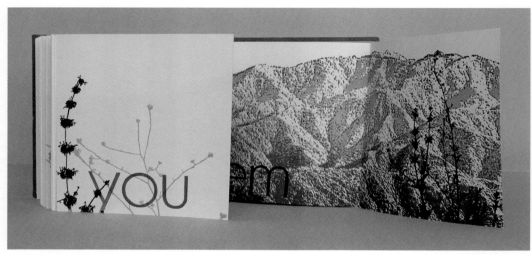

16 "Ornaments can be placed in the paragraph indents, but few texts actually profit from ornamentation." Robert Bringhurst, *The Elements of Typographic Style* (WA: Hartley & Marks, 2004), 40.

17 "His famous axiom 'form follows function,' became the touchstone for many in his profession. Sullivan, however, did not apply it literally. He meant that an architect should consider the purpose of the building as a starting point, not as a rigidly limiting stricture. He himself employed a rich vocabulary of ornament, even on his skyscrapers." Available at: www.landmarks.org/sullivan_biography. htm (Last accessed September 28, 2012.)

18 Donald Saff and Deli Sacilotto, *Printmaking: History & Process* (New York: Holt, Rinehart and Winston, 1978), 8.

19 Saff and Sacilotto, *Printmaking*, 9.

20 Saff and Sacilotto, *Printmaking*, 38.

21 Glen U. Cleeton and Charles W. Pitkin, *General Printing: An Illustrated Guide to Letterpress Printing* revised by Raymond L. Cornwell (Illinois: McKnight & McKnight Publishing Company, reissued California: Liber Apertus Press, 2006), 62.

22 Saff and Sacilotto, *Printmaking*, 69.

23 Saff and Sacilotto, *Printmaking*, 70.

24 Read about the Chicago connection to Thomas Bewick in *Thomas Bewick, the Blocks Revisited: The Story of the Blocks in Chicago and the Provenance of the Nine Blocks at the Hesterberg Press,* Hesterberg, W., Bewick, T., v. 1, (IL: Hesterberg Press), 2002.

25 R. Michelson Galleries website. Available at: http://www.rmichelson.com/art-ist_pages/moser/Bible.htm (Last accessed September 28, 2012.)

26 http://www.moma.org/collection/theme.php?theme_id=10109 M. B. Cohn, From Grove Art Online, 2009, Oxford University Press. (Accessed September 28, 2012.)

27 Saff and Sacilotto, *Printmaking*, 82.

28 Kilgour, *Evolution of the Book*, 120.

29 Kilgour, *Evolution of the Book*, 120–121.

30 Strauss, *The Printing Industry*, 209.

31 To download the Sterling Toggle catalog, which explains the system, go to http://www.sterlingtoggle.com/Support/Default.aspx (Last accessed September 28, 2012.)

32 "We no longer use zinc because of the Michigan environmental laws pertaining to this material, which makes it impossible for us to use." Email to M. Chiplis August 7, 2012 from Brandie Albring, Customer Service Specialist, Owosso Graphic Arts.

33 Strauss, *The Printing Industry*, 214.

34 http://www.owossographic.com/Templates/MagnesiumDies.aspx (Last accessed August 5, 2012.)

35 Boxcar Press website. Available at: www.boxcarpress.com/

36 SAIC currently has two laser cutters: the 150-watt and the 120-watt. They are identical in almost every way except for the power of their respective laser tubes. The laser cutter bed is 18" x 32". The model is a Universal X2-660: 120 Watt C02 laser, PLS6.150D: 150 Watt C02 laser, Universal Laser Systems, manufacturer, http://www.ulsinc.com/

(Top left) Julia Allen, *A Moveable Feat.* 1994. (7½" x 3¾" x 1¼".) Photograph by Julia Allen. For Julia Allen, interest in her Korean and European roots inspired her to study the calligraphic brush strokes of Chinese and Korean calligraphy. Since those beautiful forms sometimes mimicked the very gestures of a person or their emotive qualities, she chose to photograph a model enacting character gestures, wearing a special garment sewn to drape in a calligraphic style. Magnesium plates were made for each character and layered into the hand-positioned letters of her verse.

(Center and bottom left) Rebecca Chamlee, *Study for the Possibility of Hope.* 2010. (6¼" x 6¼" x ½".) Photographs by Rebecca Chamlee. "The images of native California plants and the San Gabriel mountains on three double gatefold spreads connect to the view from the poet's porch where the poems originated."

CHAPTER SIX *Contemporary Processes*

Once you have become familiar with the fundamentals and traditional practices of letterpress, you can venture into contemporary processes and experimental techniques. These processes and techniques are not just meant to show how you can break the rules, and have fun doing so, but also they prompt further exploration. They tap into non-linear thought processes and appeal to painters and others coming from less rigidly structured disciplines. The goal is to keep letterpress vital and in the world today.

Some of these processes have been practiced in printmaking since the 1950s and earlier.

> In the late 1940s and 1950s, interest in the use of color in the relief print increased…In France, Pablo Picasso (1881-1973) was responsible for another major innovation in the 1950s. Using one block for multicolor linocuts, he was probably the first person to devise a reduction method: cutting and printing each color from one block until only the last color portion remains on the block…"[1]

These processes are contemporary because even though they have their base in printmaking, some are currently widely practiced in combination with traditional letterpress techniques. Others are just catching hold in letterpress, and have yet to become widespread. Innovation comes when the aesthetics and processes from one medium cross to another. We urge our students to connect typography and imagery with their own creative exploration, to result in new and exciting combinations.

These processes are all based on the principles of relief printing and a type-high matrix. A matrix is a plate used in printing; more generally, it is a supporting structure.[2] [3] An experimental matrix is a matrix created using non-traditional techniques. Some of these techniques are used in printmaking for collagraphs. "A collagraph is a print made from a collage of various materials glued together on a cardboard, metal, or hardboard plate. Plastic, such as Lucite or Plexiglas, can also be used as a support for the glued materials."[4]

One reason to create an experimental matrix is to achieve effects not possible or as easily achieved by traditional means. It is often also less expensive, and it offers an excellent opportunity to explore.

To give our students a place to start, we made some bases out of plexi mounted on wood. These are just under .918" (type high) and can be used for any of the processes calling for a blank matrix. This way, when found objects or other material are added on top, the total height will add up to .918" and no higher. Forms higher than .918" will damage the press. To measure the height of your matrix,

(Top right) Janice M. Cho, *Honesty Trumps Fame.* Metal type, quoins and wood furniture printed on Rives. 2012. (11" x 30".)

(Center right) Janice M. Cho, *Unsung Heroes.*

(Bottom right) Jenna Xu, *Inexplicably Precious Objects.* Hand set and printed with photosilk-screen images, interleaved with actual objects. 2012.

use the roller gauge, a plate gauge, or even more basically, place your matrix on a level surface next to some large type to see and feel the height.

Found Objects and Other Materials

Anything relatively flat can be brought up to type high and letterpress printed. Materials can be cut out, assembled, and mounted on top of a base. The materials are then sealed with an acrylic varnish or medium, such as Krylon Crystal Clear Acrylic. Be aware of the health issues with any spray paint or varnish. Spray in a well-ventilated area, in a spray booth if possible.

Found objects good for printing from are coins, washers, gaskets, tin cans, embossed signs, copper, aluminum, or plastic screens.[5]

Besides found objects, other materials to try are matboard, Masonite, masking tape, stick-on stars, telephone wire, doilies, string, ribbon, confetti (cut out with scrapbook punches), crinkled paper, cut paper, sheet magnets, vinyl letters, dice, Styrofoam, and "Flexi-cut."[6] Materials from the letterpress studio, such as spacing or furniture, can be used as well. In the words of Janice Cho, "it was their chance to make it onto paper." Some artists, such as Jenna Xu, prefer to include the actual objects in their artist's book, rather than take a relief print from them.

Pressure Printing

Pressure printing is also known as stratography.

> This technique came to me when a piece of string got trapped under my printing sheet while printing a color "flat."…I've since been told that other printers had made a similar discovery, such as the late Joe Wilfer who referred to this image as a "stratograph," and German printers who refer to it as "Zurichtungdruck."[7][8][9]

In pressure printing a multi-level collage, or collagraph, is created and placed underneath the printing paper as it conforms to the carriage in a printing pass, or, alternatively, is adhered to the packing. The latter has the advantage in editioning, because of its superior consistency.

Some of the visual characteristics of pressure printing are: all over color (good for backgrounds), low contrast ("atmospheric" soft edges), and interesting textures. It also has the potential for very sensitive and nuanced effects.

For the Love of Letterpress

(Top right) Ryan H. Basile, *La Lluvia* (title page). Hand set type and pressure printing. 2011. (4½" x 10¼".) Photograph by Ryan H. Basile.

(Center right) Margaret Suharov, *Disquieted* (detail). Photograph by Margaret Suharov.

(Center far right) Margaret Suharov, *Disquieted* (cover). Pressure printed and bound with burnt driftwood. 2011. (7" x 13".) Photograph by Margaret Suharov.

(Bottom right) Stacey Stern, Lockup for Steracle Press "Cardiology Cards" featuring a rainbow roll. 2011. Photograph by Stacey Stern.

(Bottom far right) Letterart Printing Studio, Business cards. Printed from magnesium plates on cotton paper. 2011. (3½" x 2".) Photograph by Mariusz Wisniewski.

Pressure printing works best with smooth, thinner paper and is often used in combination with other printing processes. Small changes (i.e. different paper, different packing) can make a big difference in the result. Lower relief collage works better than higher.

Some collage elements that are good for pressure printing include: paper, masking tape, stickers, doilies, string, dried glue, cut paper, and vinyl letters.

These can be combined and printed multiple times on the same sheet to create a complex background. Students who take the time to try pressure printing, or stratography, are rewarded with a simple low-cost way to create delicate backgrounds and imagery.[10]

Split Fountain

Also called "rainbow roll," split fountain is an inking process where multiple colors are added to the rollers simultaneously, then allowed to blend together through the oscillation of the rollers. The predominant visual characteristic of a split fountain is color or value gradation. When executing a split fountain, consider the color wheel. Choose colors that will create a desirable third color. Take into account the 1" – 1½" roller oscillation, which creates the blend. Facilitate the mix by balancing color relationships.

The split fountain process works best with larger areas of spread or blend. It may require multiple initial proofs to achieve the maximum gradation. The longer you print, the more the colors mix together. The most difficult split fountains are at opposite ends of value scale, such as a blend from black to white. When replenishing the rollers, add the ink to each area of color sparingly to maintain the gradation. The rainbow roll is parallel to the grippers; place your form in the bed correctly in relation to them.

Debossing

Don't forget the beauty of inkless printing, also known as debossing, especially when considered with the tone of the paper. Inkless debossing is the hardest to see on black paper, since you are relying on light to illuminate the debossing, and the range of tone with black paper without ink is dark grey to black. The maximum tonal range, and therefore the highest visibility, is achieved from debossing on white paper.

An alternative to printing without ink is printing with an ink color that is very close to the color of the paper. In this way, "overpunching" is avoided, which can be very hard on vintage metal type and presses. Beginners in general tend to "punch" too hard, so

and *shattered it.*

You speak, but I can't hear anything beyond the mountains
Creaking among the gusts of wind.
I can smell the thick stench of burning bows
Carried through the air from the farther seas of my mind
Where the pieces of your soul are set ablaze,
As your limbs are held bound together
In the shape of a scorched figurehead.

Disquieted;

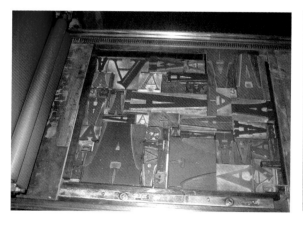

Back Home

I am interested in exploring the idea of mapping the self—something that is always shifting and changing. I try to pinpoint the catalysts for change and the underlying constants of our self-identities. In *Back Home* I have used letterpress techniques to print a topographic map of the world and mapped by hand the personal migrations of friends and family. Taking the concept of mass migration and narrowing it to those people I know… allows me to see patterns… including the overwhelming pattern of returning back home. The printed map serves as a foundation for the migration patterns. The variations in elevation are designated by feel and shadow, leaving color reserved for the demarcation of paths. The depth and tangible form letterpress gives…lends itself to visually mapping and describing terrain. Debossing… expresses variations of space and depth; to not just delineate landmasses, but to mirror and reinforce the pattern of overlapping layers in individual migration."
—*Adrienne VandenBosch*

(Top) Adrienne VandenBosch. *Back Home*. Close-up with straight pins and embroidery floss. Stonehenge pearl gray. 2010. (27" x 38".) Photograph by Adrienne VandenBosch.

(Center) Adrienne VandenBosch, *Back Home*. Debossing. Photograph by Adrienne VandenBosch.

(Bottom) Adrienne VandenBosch, *Back Home, Matrix*. Photograph by Adrienne VandenBosch.

if a student wants to do inkless printing, they are cautioned to be aware of the fragility of the materials.

Damping or Dampening

In his book, *Printing with the Handpress,* Lewis Allen states that "Damping techniques are as intriguing and as debatable as recipes for mint juleps."[11] Damping (or dampening, as some call it) paper makes printing and debossing easier on the type and press. The goal of dampening paper is to open up the paper fibers so that the surface receives ink more readily. In this way, substantially less ink can be used, and there is less wear on the type. At the moment of printing, the paper should feel cool to the cheek, not dripping wet. More information including step-by-step instructions can be found in Allen's book.

Monoprint

Every monoprint is one of a kind, non-repeatable. Rembrandt made a kind of monoprint (called a monotype) when he intentionally left a smoky haze of ink on his etched plate, giving his scene atmosphere and emotion. Matisse discovered he could lay down a flat film of black ink on a plate and scrape the ink away in a smooth, expressive white-line gesture, creating beautiful outlines of female bodies and sensual bowls of fruit.[12]

In a monoprint, ink is applied to an uncut type-high matrix, such as Plexiglass or linoleum. Paintbrushes are most often used, but the image can be created with brayers, brushes, sponges or rags. The effect is painterly and loose, and a perfect way to create gestural or textural marks to combine with type or ornaments.

To work "additively" in a monoprint, first thin the ink with a small amount of reducing oil to increase its flow and malleability. Apply the ink to the clean blank matrix with your chosen tools. Print quickly before the ink dries (disengage or raise the rollers to avoid smearing the inked up matrix). Apply the ink sparingly so that the pressure of the cylinder does not compress and spread the ink, causing it to bleed and run.

To work in a "reductive" manner, first ink up a blank matrix. Use a cuticle stick or similar tool to draw through the ink, displacing it and creating a line that will print as white. To remove larger areas of ink, use sponges or Q-Tips soaked with solvent.

Within this concept of "one of a kind," some artists deliberately choose not to edition their books. Given the complex degree of handwork involved in its illustration or binding, they create unique pieces.

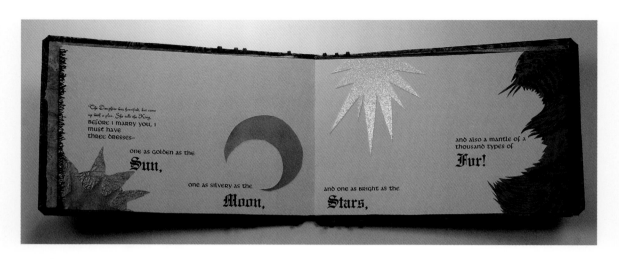

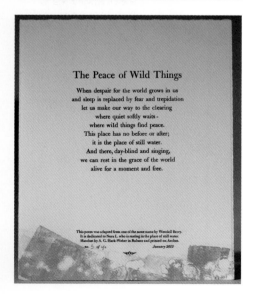

The Peace of Wild Things

When despair for the world grows in us
and sleep is replaced by fear and trepidation
let us make our way to the clearing
where quiet softly waits -
where wild things find peace.
This place has no before or after;
it is the place of still water.
And there, day-blind and singing,
we can rest in the grace of the world
alive for a moment and free.

This poem was adapted from one of the same name by Wendell Berry.
It is dedicated to Nora L. who is resting in the place of still water.
Handset by A. G. Hauk-Weber in Bulmer and printed on Arches.
January 2012

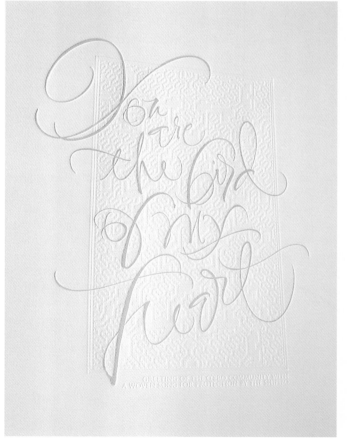

Hand Inking

Hand inking is inking by hand with one or more brayers. It is used for monoprinting, in order to print more than one color at a time, or for presses without automatic inking. In a method called "Puzzle Pieces," a brayer is used to ink up the form to print multiple colors in one pass.[13] Individual forms that are separated by some distance in the press bed can be inked up with separate colors when locked up in the bed of the press. If the forms are in very close proximity, one might need to be lifted out, inked, and replaced in the press bed.

Splatter

Splatter is a monoprint technique based on the painting style abstract expressionism. It has an energetic visual appearance, which can be a beautiful contrast to solid ink coverage and to the traditional ideal of the completely even typographic page.

 Modify the ink with a small amount of reducing oil, use a tooth-brush to splatter ink of various colors onto the block, and then print. Be sure to raise the rollers when you print, so as not to smear your work. You can also ink up the form, then splatter with solvent as a subtractive. Create a paper guard before you begin to prevent the ink from getting everywhere.

 A more controlled gestural mark making may be accomplished by hand-painting directly onto individual pages.

Ghosting

Ghosting is printing without re-inking. To make a ghost print, raise the rollers. Each successive print becomes lighter and lighter. This method is ideal for a background, or sequential, time-based imagery.

Backwards Transfer

There are two similar methods of creating a reverse from forward type or an image. Before you begin, check the height of your matrices to be sure that they are the same, and to allow for the difference in packing required for paper vs. Mylar.

BACKWARDS TRANSFER METHOD

1. Print type onto frosted Mylar.

2. Replace type with type high uncut block in bed of press.

(Top left) Sara Palazzo, *Allerleirauh*. Hand set and printed. Cut paper illustrations on pages with hand-sewn edges. Bound in leather. One of a kind. 2011. (7" x 10 ½" x 1".)

(Center far left) Lisa Beth Robinson, *Untitled*. Pressure printed on French paper to represent the ocean's continual overlap, mirroring Colm Toibin's writing about the move-ment of waves. 2011. (12 ½" x 18".) Photograph by Lisa Beth Robinson.

(Bottom far left) Amara Hark-Weber, *The Peace of Wild Things*. Hand set in Bulmer. Printed on Arches. 2012. (10" x 8".)

(Bottom left) Pamela Paulsrud/Stacey Stern, *You are the bird of my heart*. Translated greeting of the Peruvian Q'ero people. Brush lettered by Pamela Paulsrud. Polymer plates made by Stacey Stern. Letterpress printed over blind embossed Shipibo pattern on Lana Gravure. 2010. (14" x 11".)

Backwards Transfer

–Frosted Mylar (frosted side down)
–Inked wood type
–Print

–Paper
–Mylar (inked side up)
–Un-inked type high block
–Print

Printed paper
with reversed type

Floriated Initial: Incorporating Backwards Transfer

–Frosted Mylar (face down)
–Inked halftone
–Print

–Frosted Mylar: place face down
 on wood type
–Type (un-inked before transfer)
–Print, transfering ink to wood type

–Paper
–Type (inked from transfer from Mylar)
–Print, transfering ink to paper

3. Lay frosted Mylar ink side up on un-inked block.

4. Place printing paper face down.

5. Print.

Floriated Initial Image Transfer

Around 2006, Cathie and her teaching assistant at the time, Linda Lee, used this method for the first time to print a Shop poster. It is a contemporary process, but it refers to the decorated initial caps of manuscripts and incunabula. Once understood, the method is simple, but until then, even experienced printers look at the result and wonder "how did they do that?"

FLORIATED INITIAL IMAGE TRANSFER:

1. Place decorative halftone image block in bed of press.

2. Print it onto frosted Mylar.

3. Take block out of press, replace with large wood character.

4. Place Mylar face down on wood character.

5. Print, transferring the halftone to wood character.

6. Remove Mylar, lay printing paper on top.

7. Print.

Brayer Roll-outs

A press is not needed for this process. In a brayer roll-out, a clean brayer is rolled over an inked form just once, then rolled out onto a sheet of paper. The repetition of the inked form depends upon the diameter of the brayer. On longer sheets of paper, the image will "ghost" with repeated brayer rotations.

Stencil

A stencil, or mask,[14] blocks off areas of the matrix so that they won't print. A stencil has cut out areas that allow ink to be pushed through. One way to explain stencils is to think of it as a paper doily. In these

(Top) Brayer roll-out.

(Center) Leonard Seastone, *Crickets*. Ambrotype and salted paper prints. Hand set and printed on hand-made papers. 2011. (7 5/8" x 5 1/8" x 1 1/8".) Photograph by Bill Westheimer.

(Bottom) Sara Langworthy, *Morpho Terrestre* (spread with poem). Printed from polymer plates on Sakamoto paper with hand-painted Sumi ink. 2006. (11" x 20" x 1".) Photograph by Tom Langdon.

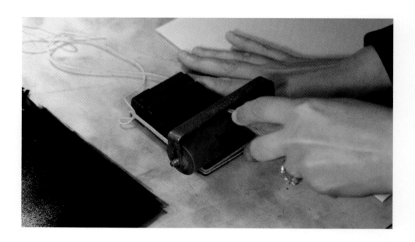

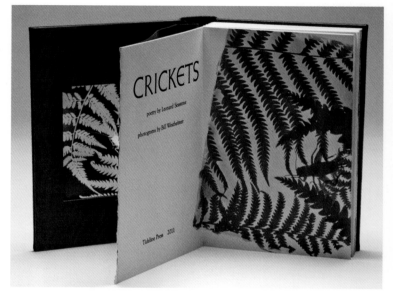

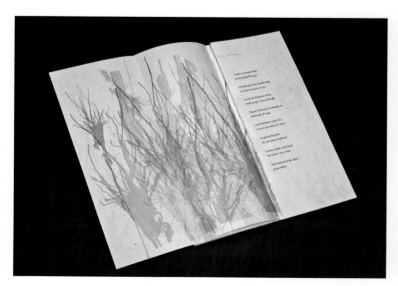

examples, doily = stencil. Stencils can be made of paper or a material such as Mylar. The advantage of Mylar is that it is reusable.

DOILY, NEGATIVE USE

1. Printing with a stencil—place an un-inked doily on top of an inked-up matrix. Print. In this case, the doily is being used as a mask, or a stencil.

2. Lay down the doily, ink a blank matrix through the doily, and then remove it. This creates an un-inked area on the matrix. Print.

DOILY, POSITIVE USE

1. Ink up the doily and place it on top of an un-inked matrix.

2. Print.

Another use of stencil allows you to print a free-form shape from a found rectangular halftone plate. In this way, the illustrative content of the halftone can be edited by the printer.

PRINTING A FREE-FORM SHAPE FROM A FOUND RECTANGULAR HALFTONE PLATE

1. Place Mylar mask down on top of the inked form.

2. Tape along the side of the mask closest to the feedboard, to attach it to the head dead bar, or the furniture. This is so that the rollers don't pull the mask off as they pass over it. Print, with raised rollers.

3. Remove the stencil before returning the cylinder to the feed board. Note: Take into consideration the thickness of the Mylar, 3 mil is recommended.

All of these processes can and should be explored. Then, once the student has tried them, they can decide which of them resonate with their own thought processes, strengths, and work habits. The processes should all be used in service of, and in harmony with a concept, and can be combined in many various ways to create innovative work.

fret

unsaid

hope resolute

SUMMER

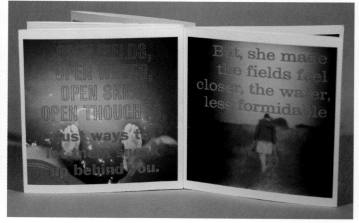

OPEN FIELDS,
OPEN WATER,
OPEN SKIES,
OPEN THOUGHTS
just ways to
behind you.

But, she made
the fields feel
closer, the water,
less formidable

PANTHERS

panthers

Notes

1 John Ross, Clare Romano, Tim Ross, *The Complete Printmaker: Techniques, Traditions, Innovations,* revised and expanded edition (London, UK and NY: The Free Press, a Division of Macmillan Publishers, Inc. Collier Macmillan Publishers 1990), 8.

2 Definition of matrix: "A supporting or enclosing structure." (UK: Oxford English Dictionary).

3 "Matrix: plate used in printing, such as the zinc copper or aluminum plate used in etching or the collage plate used in collagraph." Ross, Romano, Ross, *The Complete Printmaker,* 347.

4 Ross, Romano, Ross, *The Complete Printmaker,* 131.

5 Ross, Romano, Ross, *The Complete Printmaker,* 141.

6 Available from Dick Blick.

7 Barbara Tetenbaum *A Guide to Experimental Letterpress Techniques* (Portland, Oregon: Triangular Press, 2004).

8 One translation of "Zurichtungdruck" is "makeready print."

9 "Grooms got to work with Joe Wilfer before his untimely death and made two unusual prints, *Elaine de Kooning at the Cedar Bar* (1991) and *A Light Madam* (1992), using Wilfer's stratograph technique of building up paper to form a relief surface similar to a woodblock. Where a woodblock often reveals the texture of the wood, a stratograph reflects the more muted texture it receives from the paper, which suits the darkly-lit settings of these subjects." http://www.vincentkatz.com/abc2/books_abc2_Grooms.htm (Last accessed September 28, 2012.)

10 Thanks also to Tracy Honn for information on pressure printing. Southern Graphics Council Conference, March 20, 1999.

11 Lewis M. Allen, *Printing with the Handpress* (NY: Robert E. Krieger Publishing Co., Huntington. Reprinted by arrangement with Van Norstrand Reinhold Company, 1976), 48.

12 Ross, Romano, Ross, *The Complete Printmaker,* 246–249.

13 "Edward Munch…often printed from one block that was sawed into separate pieces, very much like a jigsaw puzzle." Ross, Romano, Ross, *The Complete Printmaker,* 32.

14 "…there are two types of stencils: positive and negative. With a positive stencil, the block-out material fills in the background and the actual image is printed. With a negative stencil, the image is blocked out and the background is printed." Ross, Romano, Ross, *The Complete Printmaker,* 157.

(Top far left) Leslie M. Ward, *The Grand Gesture* (fret/hope). Wood type on silver gelatin print fiber paper. 2010. (14" x 11".) Photograph by Leslie M. Ward.

(Top left) Leslie M. Ward, *The Grand Gesture* (unsaid/resolute). Photograph by Leslie M. Ward.

(Center far left) Christopher Givens, *Summer* (cover). Giclée printed photographs on Moab Entrada paper with hand set type. 2012. (4½" x 42¾".)

(Center left) Christopher Givens, *Summer* (spread).

(Bottom far left) Wilber H. Schilling, *Panthers.* Photopolymer and Cyanotype on handmade paper. Binding and box. 2007. (4½" x 6½" x 2".) Photograph by Wilber H. Schilling.

(Bottom left) Wilber H. Schilling, *Panthers* (spread). Photograph by Wilbur H. Schilling.

Countries producing landmines found in Mozambique:

Austria
Belgium
China
Czechoslovakia
East Germany
France
Hungary
Italy
North Korea
Romania
South Africa
Spain
United Kingdom
USA
USSR
Yugoslavia
Zimbabwe

Much as a painter might stare at a blank canvas, hesitant to put the first mark upon it, a letterpress student can easily become overwhelmed by the multitude of typefaces in a letterpress studio. Too many possibilities can result in inactivity, waiting for the best choice to reveal itself.

Mistakenly, they think that only one typeface can be the "correct" one. In other instances, the student's own desires betray their efforts. They want their solution to an assignment to be superior, and revise a preliminary idea repeatedly, hoping each iteration will be their magnum opus.

The opposite also occurs. Armed with rudimentary knowledge of how to set type and operate a press, the urge to "get printing" overtakes them. "What" gets printed is hardly important—"how well" it is printed, is considered even less.

Balancing these learning approaches is a tenuous act for an instructor, but a critical one. It should be addressed in the first weeks, since it sets the tone for the entire semester. And because the Type Shop is a communal space, this range of temperaments must be accommodated by the students as well. Fostering an environment where all feel comfortable and respect each other's individualities is the first step. The second is to establish a standard of performance that must be met, no matter what a student's disposition might be. By modeling an attitude of personal interest in each student, the instructor can introduce such a milieu.

The students' return to class after the first assignment is given out is a prime occasion to further develop this. It is also the start of numerous conversations, both group and individual, that will shape the process of critically and imaginatively developing possible conceptual solutions to the assignment.

(Left) John Risseeuw, *For Luis and Domingos*. Letterpress, woodcut, polymer relief on paper made from the clothing of Mozambican mine victims mixed with traditional African fibers and the shredded currencies of mine-producing countries. 2004. (13" x 16½".) Photograph by John Risseeuw.

Sources of Inspiration

As I sit with each student, and listen to their initial description of what the project objective prompted them to think about, I look for clues. What are they interested in? Did they draw from their personal life for a possible direction? Have they kept a journal of personal writing or a sketchbook of images? Is their cultural heritage a significant motivator for them? Could content in any of their other classes provide stimulus? Are they responding to current events or social phenomena influencing their world?

(Top right) Brian Kring, *Flying Fish*. Movable paper sculpture letterpress printed and hand colored. 2011. (2 ½" x 7 ½".)

(Center right) Jackie McGill, *Black Friday*. Printed with metal type and polymer plates. Mylar cover, endpapers of 2010 newspaper advertisements. 2010. (5" x 8" x 1".) Photograph by Stephen DeSantis.

(Bottom right) Flowers and Fleurons, *Tower of Babel*. Wood and metal type, including the backs of the type blocks printed on Somerset Book. 2010. (36" x 13".) Photograph by Flowers and Fleurons.

Often there is a layering of intent at play. One foreign exchange student discussed doing a recipe book for the freshman college student. With gentle but probing further conversation, it became clear that she was actually "hungry" for her family back home. The project matured into a collection of savory dishes, evocative of her native culture, but able to be prepared by a young adult on a limited budget.

Sometimes students are stymied by an assignment's parameters, and must be further encouraged to create a concept. In such cases, examples of other students' work—and lots of them—are beneficial. If I can recall and verbally share the "gestation" of any of these examples, even more of the conceptual development is manifest for them. Students can then apply it to their own interests and move forward with ease.

Reviewing historical precedents is another valuable prompting mechanism. Sensing some affinity in their initial idea with a prior period in art history, I might direct them to investigate a particular style or movement or artist/designer. This approach may extend to other disciplines as well, such as biology, mathematics, or literature. For instance, a stream of consciousness author might be the best reference for a student building a letterpress broadside by intuitive reaction to each previously printed run.

Looking at historical specimens not only serves as inspiration, but it also teaches the typographic and design rubrics of another time and place. The student builds a chronological database, which will help inform future work as well as the current project.

Another stimulating source of inspiration is collaboration. There is a unique synergy that occurs when creative individuals are in dialogue with each other. Fueled by each other, they build a momentum. The inherent support system carries them through difficult segments of the process. The caliber of achievement is also often heightened because each of the partners strives to meet the expectations of the other, as well as themselves. One of my past students collaborated long-distance—with a friend on the other side of the country. Her friend initially wrote a short prose piece and emailed it to my student. She responded with a torn paper collage that she pressure-printed. Sending that scanned image back to him, he then wrote a sequel passage. He sent that to her, and the exchange continued, with a book that exceeded both of their expectations.

"Kindling"

I tend to think of my first "concept" discussions with students as "kindling;"taking the material they have gathered, and starting a

(Bottom right) Amelia Bird, *Holes*. Pamphlet structure, enclosed in cloth, Japanese portfolio with embossed title. Original essay handset in Joanna with hand painted sumi and India ink on partially waxed Japanese paper. "The short essay in *Holes* is about the artist's younger brother's relationship with digging holes in the yard when he was a child. Carson's holes, like many youthful games, start out as innocent experiments but end up being repurposed in ways he never could have anticipated, and they give insight to what kind of man he will become. Visually, the way the text, wax, and ink move down the page, accumulating weight from behind as the story progresses, mirrors both the act of digging a hole and the gathering of experience that can occur in our own backyards." 2010. (10 ½" x 5 ¾" x ¼".) Photograph by Amelia Bird.

(Top right) Julie Chen, *Panorama* (title page). Letterpress printed from photopolymer plates and wood blocks. Large format pop-ups and interactive folded sections explore the issue of climate change from an artist's perspective. 2008. (9½" x 20¼".) Photograph by Sibila Savage.

(Center right) Julie Chen, *Panorama* (spread). Photograph by Sibila Savage.

(Bottom right) Alastair Johnston, *Logbook* (title page). Hand set by Alastair Johnson. Printed by Frances Butler on dampened Arches. Text consists of random pages from a ship's log. 1976. (12" x 8½" x ½".) Photograph by Grace T. Gomez.

(Bottom far right) Barbara Hauser, *The Yule Log*. Christmas card. Type and copper engraving printed on dampened Fabriano Tiepolo. 2011. (11" x 7¾".) Photograph by Barbara Hauser.

spark that ignites them to go on. I pepper them with tried and true journalist questions: "What do you want to say about that idea?" "To whom do you want to say it?" "Why do you want to communicate that?"

Often the student does not know the answer to a question, and I reassure them that that is fine. If we have opened up more possibilities, or probed deeper than where they were before, our dialogue has been successful. The ember is smoldering, and at the next conversation, it is almost always aflame.

"Winnowing"

Our second one-on-one conversation is usually a "winnowing" process: extracting or selecting the best concepts from the many that have proliferated since last we spoke. Customarily, students have researched several of the avenues that we initially discussed, and are excited to present stronger, more solidified ideas. The objective of this dialogue is a very different one. "How can the media of letterpress enhance that concept?" "What are the aspects of your concept that can be visualized through font selection, spacing, placement on the page, ink color, paper choice?" "Can you envision one of the concepts utilizing these materials and design principles more effectively than another?" Sometimes it is a combination of ideas that coalesces into a single concept; other times it is a distillation and refinement of one.

Time Management

Throughout the conceptualization process, I try to be mindful of time. Emphasizing to the students that this is only one portion of a continuum that also includes design/layout, setting, proofing, editioning, and binding allows them to configure a schedule that will accommodate all phases. If too much time is invested when developing a concept, the production end of the continuum, including quality craftsmanship, most often falls short. During each of the phases, challenges may arise. It is critical to allot time for mistakes, revisions and "starting over."

The gravity of developing a sound concept cannot be understated. The student must be propelled by his own investment in the authenticity of that idea because its accomplishment will take some time. Letterpress, by its very nature, is a slow process; that which is committed to print should be exemplary of that endeavor. The artifact itself will live on, evidence of the mind and heart of the printer, and the spirit of his time.

For the Love of Letterpress

He arrived at his ancestral home. The guest quarters had long been filled with others who had come for the census, but off the courtyard was a deep alcove where, in springtime, milk-goats and wool-sheep were sheltered with their newborn kids and lambs. That room, removed and quiet, would serve well as a nursery for the child who soon would be born to his young wife. He worried, though, that the room was not warm enough, so he went to gather wood for a fire he could build on the earthen floor at the chamber's edge. In the nearby forest, he saw that a once-stately oak had been felled by lightning, its gnarled, singed trunk lying on the winter underbrush. He cut a large log and returned to the nursery just as his wife's brief, untroubled labor began. The log burned all through the night, its light the first seen by the new baby. At dawn, all that was left was a single ember. The infant's mother drew it from the ashes. She would use it to kindle the fire that would warm her new son's first birthday.

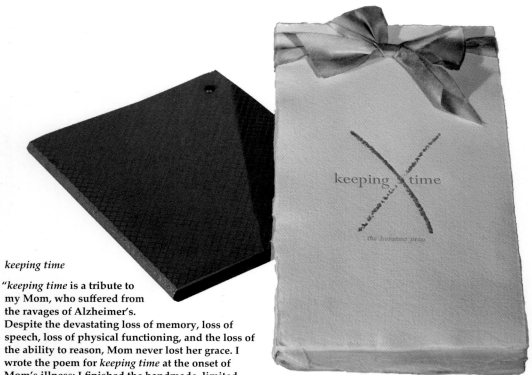

keeping time

"*keeping time* is a tribute to
my Mom, who suffered from
the ravages of Alzheimer's.
Despite the devastating loss of memory, loss of
speech, loss of physical functioning, and the loss of
the ability to reason, Mom never lost her grace. I
wrote the poem for *keeping time* at the onset of
Mom's illness; I finished the handmade, limited
edition letterpress artist's book nearly sixteen years
later. During the course of that time, I saw Mom
disappear before my eyes. The elegant, vibrant woman
you see upon the pages was reduced to a mere shell.
The constant repetition of the same answers to Mom's
same questions—a hallmark of the early stages of the
illness—eventually gave way to her not even being
able to recognize or speak to her own daughter. The
format of the artist's book allowed the ideal oppor-
tunity for the reader to experience this same trans-
formation. I wanted you to not merely witness, but
also palpably feel the diminishment an Alzheimer's
patient must endure. By repeating images (like Mom's
own handwritten 'X' marking days on the calendar
which had passed), repeating phrases ('just to make
sure', 'just to make sure'), you the reader, turn the
pages of Alzheimer's time."
—*Cathie Ruggie Saunders.*

(Top) Cathie Ruggie Saunders, *keeping time*
(title page). Hand set Perpetua printed on Barcham
Greene's Camber Sand, interleaved with Japanese
dark Gampi. Kaga Yuzen Shibori pattern sleeve with
Italian pearl diver silk ribbon. 2003. (4" x 7¼")

(Bottom) Cathie Ruggie Saunders, *keeping time*
(spread). Original photograph of Mom by Alexander
N. Ruggie, M.D.

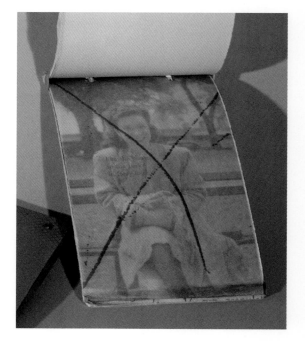

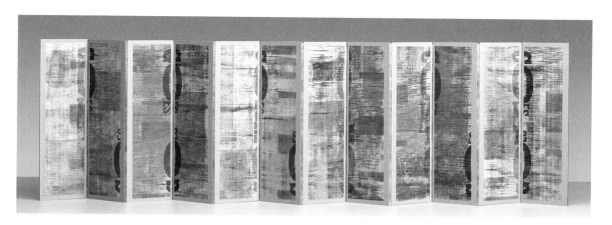

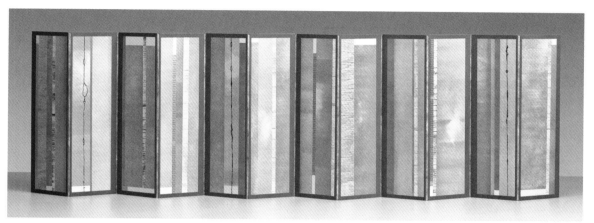

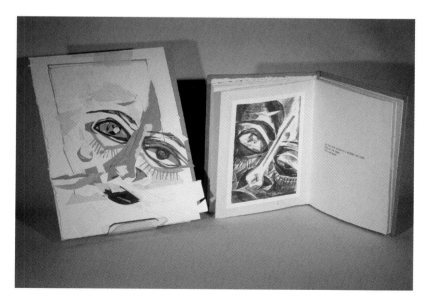

(Top) Lynne Avadenka, *Fleeting Days II* (front). Letterpress printed screen. Text from the Book of Ecclesiastes, printed and overprinted. 2010. (64" x 6".) Photograph by R. H. Hensleigh.

(Center) Lynne Avadenka, *Fleeting Days II* (back). Photograph by R. H. Hensleigh.

(Bottom) Leksi Linne, *Perfectly Good Craters.* Book and paper collage template. Text letterpress printed on Rives BFK. Images pressure-printed on Rives Lightweight. 2009. (9 ½" x 7 ½" x 1".)

An Afternoon in the Shop

In SAIC's 1308 letterpress shop, four printers gathered to create an unplanned book, each working on a different press. Various edits, additions, and commentary were added to each individual page to create a flowing narrative. Each printer was given one hour to hand set their response, ink, print, and pass each page off to the next printer. Completed April 26th–30th, 9–6pm.

(Top) Mary Louise Killen, Louisa Shields, Lauren LoPrete, Julia Asherman. *An Afternoon in the Shop* (spread). Various typefaces on Rives Heavyweight Off-white. 2009. (8" x 8".) Photograph by Mary Louise Killen.

(Center) Mary Louise Killen, Louisa Shields, Lauren LoPrete, Julia Asherman. *An Afternoon in the Shop.* Colophon. Photograph by Mary Louise Killen.

(Bottom left) David Wakefield, *Invesco Question.* 23 Press. Created with letterpress wood and metal type for a series of advertisements for Invesco Banking. 2006. (11" x 7".) Photograph by David Wakefield.

(Bottom right) David Wakefield, *Invesco Question.* 23 Press. Final print advertisement. Photograph by David Wakefield.

(Top) Janice M. Cho, *The Valiant Vandercook Bakery* (cover). Hand set and printed on cold-pressed Arches. 2011. (5" x 6" x 2".) Photograph by Janice M. Cho.

(Center) Janice M. Cho, *The Valiant Vandercook Bakery* (spread). Photograph by Janice M. Cho.

(Bottom left) Barbara Hauser, *Tomato Sandwiches*. Lockup. Photograph by Barbara Hauser.

(Bottom right) Barbara Hauser, *Tomato Sandwiches*. Two-sided recipe card printed on dampened Somerset Velvet from hand set type and copper photo engravings. Hand colored. 2010. (5" x 7 ½".) Photograph by Barbara Hauser.

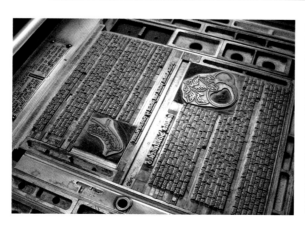

8

a flower unfolding

flags blowing in the wind

childhood games and toys

the kitchen junk drawer

a deck of cards

a Japanese paper fan

an old love letter in a postmarked envelope

that dime store diary with tiny brass lock and key

knife pleats in a school uniform skirt

closing the blinds at night[1]

(Left) Barbara McDonald, *Dziadzie* (open). Hand set and printed on Frankfurt White and handmade papers. 1990. (7" x 7".)

Structural Possibilities

Ordinary objects and simple activities in one's life can metaphorically inspire an abundance of book structures. Bookmaking and bookbinding texts even refer to some of these by name: flag book, Jacob's Ladder, fan book, accordion, blinds book. Here in the Type Shop, when we take our collection of blank structural models out for the students to view, many see books for the first time as something other than the traditional Western codex, at home on a bookshelf, spine facing out.

The blank models are particularly useful in opening their eyes to the diversity of structural formats that might house their concepts. Without content in them to read, students are able to focus upon the form, and see it for the attributes it confers upon a viewer's reading experience. We discuss those attributes, model by model.

Relationship of Content and Structure

An accordion or concertina format, for instance, presents a continuous set of picture planes, viewable panel by panel, or outstretched all at once. The sense of time displayed therein can be punctuated by a viewer's pause as he turns each set of panels, or as an uninterrupted visual flow if it is viewed extended as a screen. If it is displayed as a self-standing, three-dimensional screen, the viewer then encounters it "at arm's length"—quite differently than most

(Top right) Barbara McDonald, *Dziadzie* (closed).

(Top far right) Suzanne Sawyer, *Mind the Hives.* Letterpress printed using photopolymer plates on fresh wet sheets of Kozo and formed around an armature. Text from an old bee-keeping guide. Unique. 2011. (6" x 14" x 10".) Photograph by Teresa Golson.

(Center far right) Suzanne Sawyer, *Mind the Hives* (detail). Photograph by Teresa Golson.

(Center right) Tennille Davis Shuster, *Unearthed* (detail). Photograph by Tennille Davis Shuster.

(Bottom) Tennille Davis Shuster, *Unearthed.* Handmade pineapple paper, woven palm frond-wrapped covers. Flag book format with palm frond pages. Part of a poem by Edna St. Vincent Millay: "I can push the grass apart and lay my finger on thy heart." 2005. (9" x 9" x 2".) Photograph by Tennille Davis Shuster.

book-reading experiences. We ask the student, "Is it important to have the viewer hold the book?" If so, this might not be the format for your idea.

Consideration should be given to the backside of an accordion format. Will the viewer stop reading at the last panel of the front side, or do you want him to continue around to the back, and return to the starting point? Does your concept correlate with that "closed loop" resolution? Is it a cyclical idea that you are presenting? If a paper with some transparency is used, hints of the other side would be apparent throughout the reading process. Would that enhance your concept? Since the pages may be hinged together, an accordion format is capable of considerable length—and therefore girth. Do you want a sleeve or band to keep the closed book shut? Removing such a sleeve will add a bit of time to the entering of the reading experience—which can heighten the anticipation of what the book will disclose. Where should the band be situated? Centered? Could it play a role in the entry experience by partially hiding/revealing printed portions of the cover?

An accordion structure dictates a fixed sequence of picture planes. If a student's concept is best served with a random set of "pages," we discuss structural options like boxes, ready-made containers, folders with pockets, even purses, and army ammo bags. We keep dozens of bookmaking, design, typography, and history books in the Shop, as well as book arts exhibition catalogues. Whether the student needs technical advice, a historical reference, or simply a feast of inspiration for their eyes, it is sure to be found.

The Function of Dummy Structures

By urging the student to integrate structure and content, form and concept, we underscore this fundamental tenet of our approach to teaching bookmaking. Since we are working with the tactile media of letterpress, we stress that the choice of physical materials must also relate to that structure and content. This hierarchy anchors the student's decision making from start to finish, through the typographic selections, through the layout roughs, to the editioned piece. Along the way, students create physical mock-ups or "dummy" structures. A pencil or computer-generated one is created first, depending on the student's preference, sometimes from folded bond or scrap paper. Indications of text and image are noted. Each time the student explores a different structural format, a separate

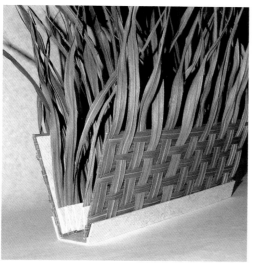

corresponding mock-up is made. Since the emphasis is upon exploration at this point, these are considered preliminary mock-ups.

After the type is set and proofed, a true, working mock-up is created of the preferred structure, using those proofs. Cutting and pasting them into the new dummy makes visible the maturing of the student's vision of their book. This mock-up should be actual size, and indicate type choice and placement, grid (or no grid) referencing, negative space, number of pages, etc. You could also make this dummy by using test proofs on your actual paper stock. In this way, you can also gauge the correct punch, and see how long the ink takes to dry.

A third, a printer's dummy, is indispensable in page set-up within the bed of the press, as it is easy to get confused with imposition. This dummy shows 2 or 4-up page positioning, page numbers, front to back positioning, colors and illustrations. Each print run is indicated separately on it. Keeping track of what has been printed and what hasn't is easy with a printer's dummy. It also serves as a subtle incentive; the student can check off the pages printed, ever nearing toward completion, and the visual realization of their concept.

And finally, a blank binding dummy using the actual edition paper is encouraged. Will the sheet take a stitch without tearing? In quantity, some sheets reveal characteristics that in sparser stacks would not be evident. With the number of signatures needed for your book, will the proposed binding structure function well? Other important considerations are discussed in a later section, Choosing Appropriate Paper.

Choosing Appropriate Typefaces

How does a student begin to choose a font from the plethora of options in a Type Shop? A common inclination is to select a face that they know, perhaps one they have worked with on the computer, or done a research project about in another course. Many students have "favorite" fonts, gravitating toward their repetitive use, reluctant to stray from them.

Others simply become enchanted, like a child in a candy store, when they pull open a drawer of a highly ornamented or unusual font they have never seen before. Setting and proofing these beauties is sometimes enough to satiate their appetite for novelty. Other times the instructor must gently coax them toward more critical paths of discernment. Is their concept era specific? Would choosing a font designed in that era be most appropriate? Perhaps it is

geographically specific; researching font designs from that country might offer a likely candidate.

How is the emotional tenor of the piece best elucidated? Since every font carries an expressive personality, strive to match that to your concept. Robert Bringhurst, in his book *Elements of Typographic Style,* speaks eloquently of this philosophy.

> You are designing, let us say, a book about bicycle racing. You have found in the specimen books a typeface called Bicycle, which has spokes in the O, an A in the shape of a racing seat, a T that resembles a set of racing handlebars, and tiny cleated shoes perched on the long, one-sided serifs of ascenders and descenders, like pumping feet on the pedals. Surely this is the perfect face for your book? Actually, typefaces and racing bikes are very much alike. Both are ideas as well as machines, and neither should be burdened with excess drag or baggage. Pictures of pumping feet will not make the type go faster, any more than smoke trails, pictures of rocket ships or imitation lightning bolts tied to the frame will improve the speed of the bike.
> The best type for a book about bicycle racing will be, first of all, an inherently good type. Second, it will be a good type for books, which means a good type for comfortable long-distance reading. Third, it will be a type sympathetic to the theme. It will probably be lean, strong and swift; perhaps it will also be Italian. But it is unlikely to be carrying excess ornament or freight, and unlikely to be indulging in masquerade.[2]

If the font complements the content, if it is appropriate and attractive for the intended audience, and if it affords legibility and readability, it is most likely a serviceable choice.

According to Phil Baines and Andrew Haslam, "text types (often regarded as being less than 14pt.) should generally be rather 'self-effacing': the idea is to read the words rather than notice the typeface. For display use, however…designers might choose something more attention-grabbing, and might give added meaning by employing a typeface with strong associative powers."[3] The American typographer and writer Beatrice Warde, articulated this call for clarity in printing and typography in 1930 in an essay entitled "The Crystal Goblet,"[4] which has since become common reading for students of typography and graphic design.

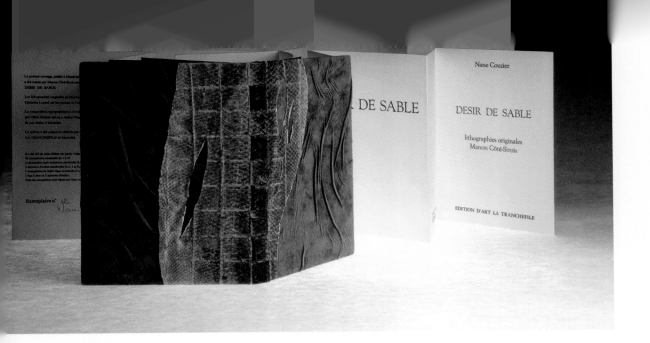

Choosing Appropriate Paper

"It is easy to get caught with a beautiful paper which is just not right."
—*Matthew Tyson*[5]

Japanese paper thin as translucent tissue.

Paper handmade from my father's intern pants.

Nideggan, a German mouldmade with beautiful wavy laid lines and a subtle drape.

Fabriano Roma, an Italian paper in a rustic array of colors, with a watermark of a she-wolf feeding her twins.

The incomparable Rives BFK, sensitive, elegant, forgiving.

Brown kraft paper.

Newsprint.[6]

With paper choices almost as diverse as typeface options, selecting an appropriate substrate can be an equally formidable task. Letterpress halftones are best printed on a paper with a clay coat so that the ink stays on the surface of the sheet and doesn't distort the halftone dots. The two technologies, halftones and clay-coated paper, were developed together.[7] Color, texture, weight, deckle or no deckle, are some of the characteristics of a paper that should be considered in relation to the concept of the project. Is your subject delicate and strong? Consider Japanese kozo paper, which can be dyed many different colors. Is it about dirt and bits of moss? Thick brown sugikawa paper, made from kozo and cedar from the Kito region in Japan, and bright green kozo paper, might be perfect.

Consider both the practical and aesthetic aspects of your choice. Can you afford enough sheets for a reasonable edition? Can you procure more if you run out? Though there are stunning papers with butterfly wings, bark and feathers embedded in each sheet, be wary of printing upon them, as they could easily crush your type. Save those for end sheets or cover papers. Think of the tactility of the paper as you decide what to use. Does it feel good to the touch? Will it absorb the ink well? Dry in the time it should? Take the impression you desire? Will it last as long as you want it to? Handle the paper, hold it up to the light, look through it. Listen to what papermakers call the "rattle." For a movable part of a book such as a sleeve, flap or pop-up, test whether the paper will endure repeated handling without abrading. Fold it, stitch it, watercolor upon it. Subject a sample sheet to the treatment your book or print will be subjected to. Then make your choice.

(Top left) Jonathan Tremblay, *Désir de sable* (Desires of Sand). Written by Nane Couzier, illustrated by Manon Coté-Sirois, published by Tranchefile édition d'art in Montréal. Lithographs by Christian Lepoul at atelier GRAFIA in Montréal. Hand set and printed by Gilles Bédard, Montréal. Piano hinge binding with concertina unfolding textblock. Binding of pig suede leather in nude color, softly wrinkled, wrapped around the spine with smoked salmon skin, hand tinted to the color of raw umber, altered, and selectively heightened in fine gold. Printed 1986, bound 1998. (8 ⅝" x 6 ⅛".) Photograph by Denis Larocque.

(Center left) Painted Tongue Studios, *Diameter of the Bomb* (closed). Interactive Broadside. Letterpress printed in silver and transparent white on Rives BFK Black. Design, illustration and concept by Kim Vanderheiden. Printing and assembly by Bill Denham. Color was chosen to emphasize a haunting quality and evoke a sense of tragedy. 2007. (35" x 35".) Photograph by Luz Marina Ruiz.

(Bottom left) Painted Tongue Studios, *Diameter of the Bomb* (partially open). Photograph by Luz Marina Ruiz.

(Top) Felicia Rice. *El alfabeto animado/The Lively Alphabet*. Includes hand-knit finger puppets set in scenes drawn by Felicia Rice, printed at Moving Parts Press on a rainbow of cloth from Cuzco. 2009. (19¾" x 25½" x 3".) Photograph by R. R. Jones.

(Center) Mary Louise Killen. *Co-Authored Colophon*. Installation. Hand set and printed broadsides. Text from historical colophons with titles of book set in an untitled typeface designed by Mary Louis Killen. Set of nine. 2009. (16" x 13" x 3".) Photograph by Mary Louise Killen.

(Bottom) Mary Louise Killen, *My Mortal Enemy*. Part of the *Co-Authored Colophon* series. Photograph by Mary Louise Killen.

Paper can be extremely seductive. Blindingly so. Laying one's eyes on the most beautiful polka-dotted sheet you've ever seen can quickly sway you from the goal that brought you to the paper store in the beginning. I doubt there is a letterpress printer who hasn't bought a sheet (or two or three) of a paper that was irresistible, rationalizing to herself that she will eventually use it. In due time, she will think of something "perfect" to print upon it. And speaking from experience, I often do.

Aiko's was a legendary paper store in Chicago from the mid 1950s until 2008. Walking into Aiko's was like walking into a church for paper. The ambiance of the store was meditative and inspiring at the same time. Long low oak tables flanked the space. On the wall, was a gridwork of cubbyholes, with paper swatches hanging from each, well worn from repeated touching. Each had exotic and ethereal names like Kitikata, Sekishu, and Torinoko. Aiko's staff would withdraw from a niche the long luscious bundle of Japanese paper you might want to see, and unrolling it reverently, lay it on the oak table. If you were a "regular," they might let you peek through the stack, and hand-select the sheets with the longest deckles, or the most flecks of silver mica. Once, when I went with a dear friend from Oklahoma in the 1980s who had never been to Chicago, we got there about an hour before closing. Mesmerized by the beauty and rarity and fragility of the bounty before us, we lost track of time. A young man named Chuck, who had been helping us, never once looked at his watch or hurried us along. It was more than an hour past closing when we finally left. That's how Aiko's was.

In early 2008, unable to compete with the likes of the art megastores, Aiko's announced it was closing its doors for the last time. After a final sale of vastly-reduced stock for its loyal customers, Chuck Izui, who had risen from stock boy to owner after Aiko Nakane retired, rolled up a huge assortment of the remainder of papers, and sent them to me, as a thank you for the many years my students and I had been dedicated customers. That's how Aiko's was.

Choosing an Appropriate Color Palette

Although color can masquerade as being simply a personal whim, when the palette chosen is referential to the concept, a stronger unity within the overall printed artifact is achieved. Students are encouraged to examine their idea, text, and images for color clues—whether they are directly stated or psychologically inferred. Gravitating to an all-purpose, one-size-fits-all color solution is discouraged. Here, again, it is important to ask the student, "Why"? Are they using

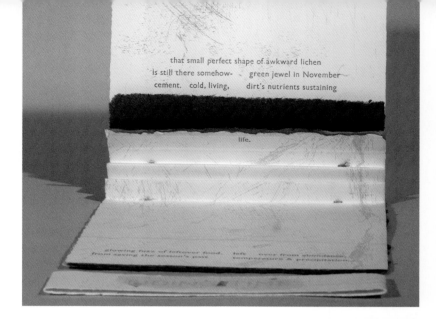

(Top) Martha Chiplis, *Biding Time*. Etching and Letterpress, Gill Sans on Rives BFK and Japanese Papers. 1989. (5½" x 5½".)

(Center) Mark Lintott, *Un jardin au bord de l'eau*. Editions Verdigris. The text is based on the author's childhood memories in the 1920s. "We conceived the book as a... river with his childhood garden reflected in it. Text and images... create the movement of the water." Hand set and printed on Hahnemülhe. Judith Rothchild engraved and printed the full page mezzotints. 2008. (8" x 12" x 1".) Photograph by Mark Lintott.

(Bottom) Michael Caine, *Zaoumni*. Colophon page. Hand set, printed homage to Aldo Novarese. Burin engravings on wood and plastic. 2000. (17½" x 12½".) Photograph by Michele Garrec.

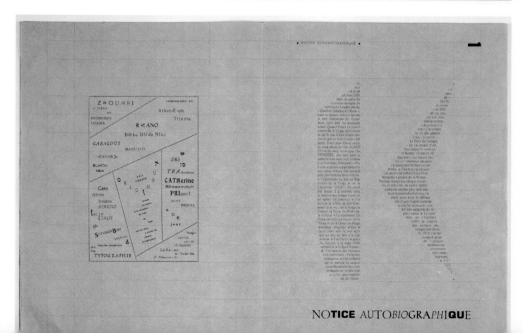

black simply because they are in the habit of pulling it off the shelf for proofing? Did they even consider a hue?

If students do want an ink other than black, we urge them to go beyond "straight out of the can color." Adjusting that color by warming it up, cooling it down, or nudging it toward another color in the spectrum is encouraged and demonstrated in the Type Shop. In this way, it takes on a personalization nuanced by the student's aesthetic.

A standard color wheel hangs at the ready next to the inking station. Complementary colors and tertiary colors are tried and true combinations. Pantone books expand students' awareness of color possibilities, and let them fan swatches next to each other to see compatibility. But we also encourage taking inspiration everywhere from nature to the annual color forecasts, such as the one sponsored by Pantone that appears in Graphic Design USA (www.gdusa.com) each May.

We suggest that the student develop their entire repertoire of colors for a project at the start. In this way they can add even the smallest bit of one color in the palette to another, and help establish a threshold of harmony among all of the inks used. Looking at draw downs of all of the colors, next to each other, and prior to editioning, can also save time. Cleaning the press after pulling a proof and realizing that color is not what you wanted, or working well with the others on the page, can be frustrating and time-consuming.

The Colophon

The last printed page in a book, the colophon,[8] has traditionally been considered the scribe's or printer's page. Early manuscripts included a signature and date by the copier of the book, and sometimes a short phrase about themselves, their location or the reason why they undertook the writing of that particular text. This custom was carried over by early printers, who expanded the information to "contain apologies for mistakes or self-praise for their absence, and sometimes, paeans in honor of the new and wonderful art of printing."[9] Many were equally interesting typographically, as they were printed in the shape of a funnel, diamond, goblet, pyramid, or very often, an inverted cone, the lines tapering off to a short line or a word. With the development of the private press movement from around 1890, colophons became conventional in private press books, and included data on paper, ink, typeface, binding, and edition size, as well as the printer, designer, and illustrator.

Modern colophons run the gamut from being bullet-point brief to waxing poetic. I have even seen colophons longer than the book text itself! Since it is the opportune place for the printer to reflect

(Top right) Cathie Ruggie Saunders, *Lullaby*. Hand set and printed in Companion Old Style. Cresent cradle boats of cherry, oak and walnut, hand crafted by Mark Ruggie. 1987. (7" x 3".)

(Bottom right) Cathie Ruggie Saunders, *Lullaby*. When lifted and opened, the Frankfurt White pages roll and wave, cascading to the rhythm of the poem.

upon his experience setting and printing the book, reading it, for the viewer, can be a glimpse into the genesis of the artifact they now hold in their hands.

For the letterpress student, it is a chance for them to mark this creative point in time. When read at a future date, the colophon has the wondrous ability to transport the printer back to their younger self, the individual that patiently committed that concept to posterity in the form of a letterpress book.

Envisioning the object is facilitated by multiple conversations with each student. Creating a structural form that embodies a concept, and designing a layout for each page of that form—from title to colophon—demands an understanding of typographic, paper, and color unity, and an awareness of the reading process a viewer experiences as he moves through the book. Letterpress printing confers a quality of tactile presence upon that object. It alludes to the thoughtful care that went into the selection and placement of each character, space, and leading.

What the student holds in his hands after the last sheet of paper in the edition is printed, is a totality of material accomplishment mirrored only by the completeness of investment he brought to the process of learning.

Notes

1 Cathie Ruggie Saunders.

2 Robert Bringhurst. *The Elements of Typographic Style* (Point Roberts, WA: Hartley & Marks, Publishers. 1999), 95.

3 Phil Baines and Andrew Haslam. *Type & Typography* (NY: Watson-Guptill Publications, 2002), 105.

4 Jacob, H. ed, Beatrice Warde, *The Crystal Goblet: Sixteen Essays on Typography,* (London: Sylvan Press, 1955).

5 Silvie Turner, *Which Paper? A Guide to Choosing and Using Fine Papers* (Design Press, 1992), 97.

6 Cathie Ruggie Saunders.

7 "But by 1900 halftone reproduction—and the results obtained on the clay-coated papers created specially for the new process—had advanced so greatly that staff artists and engraving departments could be dispensed with altogether." Susan E. Meyer. "American Illlustration: A Brief History." Available at: www.hcc. commnet.edu/artmuseum/illulstratingct/essay.asp

8 Origin: early 17th century (denoting a finishing touch), via Late Latin from Greek *kolophon*, "summit" or "finishing touch."http://oxforddictionaries.com/definition/american_english/colophon

9 www.jewishvirtuallibrary.org/jsource/judaica/ejud_0002_0005_0_04531.html

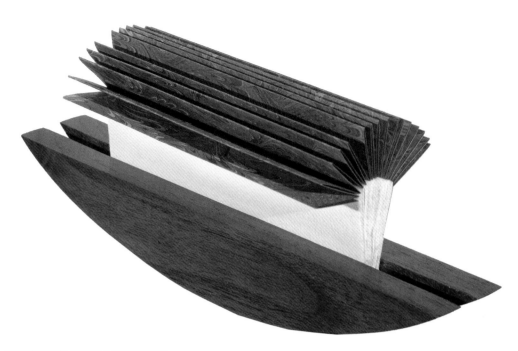

CHAPTER NINE *Assessing the Object Envisioned*

I WAKE SOMETIMES WITH THE
THOUGHT THAT I HAVE LOST
SOMETHING BEYOND MY GRASP,
BUT ONE DAY I HOPE I WILL
WAKE TO UNDERSTAND WHAT
IT WAS AND IF IT MIGHT, IN
SOME CAPACITY, HAVE BELONGED
TO YOU, AND IF BY GIVING THAT
PART OF MYSELF TO YOU, I HAVE
INADVERTENTLY KILLED A PART
OF ME.

F ew things strike fear in a student's heart more than the word "critique." After working on a project for weeks, the thought of having an instructor evaluate their efforts in a few summative sentences, causes anxiety. Presenting that work in front of their peers— "baring their creative soul"—takes courage, which is often in short supply when project deadlines approach.

Aside from anxiety, many students withdraw from participation in a critique session because they are tired from working on the project, and simply want it to be over. Feeling that their job is done, a class session devoted to assessing work is "after the fact," and therefore pointless. Still other students just don't know what comments to make or what questions to ask.

Preparation for critique may alleviate some of these concerns. And it is both the instructor and the student's responsibility to come to the critique prepared. For the instructor this means providing (either orally or written) a definitive list of objectives that the project encompassed, and communicating the responsibility each student has in contributing thoughtful analysis to the discussion.

For the student, this means stepping back from his or her own work and looking at it without the investment of ownership weighing on their shoulders. Does it meet the project parameters? Does it accomplish what the student intended? Can the student articulate their rationale for the typographic and design decisions that they made?

Since students have, ideally, conversed with their peers in the Type Shop during the process of working on a specific project, we remind them that this "in-process" knowledge will aid in their discussion contributions. Hearing one's peers address their work in the more formal situation of a final critique acknowledges that their piece functions beyond friendship boundaries and competes in the larger world of handmade art objects. Reviewing the in-process conversations the instructor has had with each student during each class session can also provide an architecture for contemplation.

A preliminary introduction by the instructor as to the practice and value of a critique helps define the process and importance of this type of public assessment. Traditional sources (such as Edmund Feldman's 1973 "Model of Criticism" from *Varieties of Visual Experience*[1]) speak of a series of four steps: description, analysis, interpretation, and evaluation. Oftentimes, this sequence works well for initial critiques in a letterpress course. Having students follow this rubric as they discuss work hones their persuasive oral skills. Verbalization helps clarify conceptualization; articulation reinforces knowledge and memory.

(Left) Alyse Benenson, *I Tried to Forget, But...* Multi-media installation with letterpress printing, vinyl wall text. 2010. Photograph by School of the Art Institute of Chicago.

Critique: Derived from the mid seventeenth-century French, based on Greek *kritike teckhne* "critical art." Now, commonly understood as an oral or written discussion strategy used to describe, analyze, interpret, and evaluate works of art.

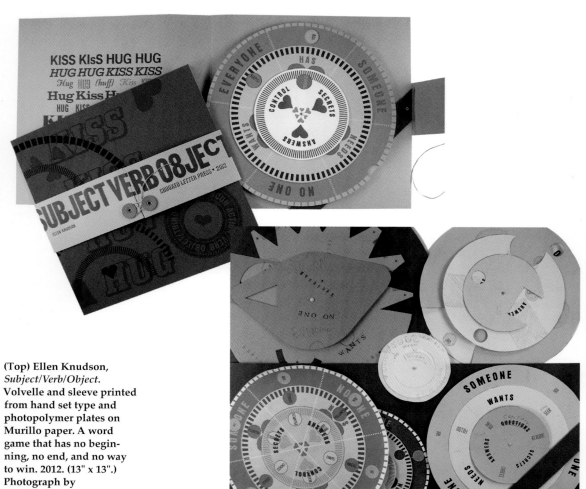

(Top) Ellen Knudson,
Subject/Verb/Object.
Volvelle and sleeve printed
from hand set type and
photopolymer plates on
Murillo paper. A word
game that has no begin-
ning, no end, and no way
to win. 2012. (13" x 13".)
Photograph by
Ellen Knudson.

(Middle) Ellen Knudson,
Subject/Verb/Object
Mock-up. Photograph
by Ellen Knudson.

(Bottom) Vida Sacic,
Cityscapes. Letterpress
printed from photopolymer
plates on Cranes Lettra at
Columbia College Center
for Book and Paper Arts,
during a summer residency
with assistance from Jackie
McGill. *Cityscapes* is
further supplemented
by iPad animations. 2011.
(8" x 6" x 1".) Photograph
by Vida Sacic.

132

Critique Format Models

However, introducing variety to the critique format is essential. Doing so provides a venue of participation for all kinds of learners; it also keeps everyone alert. Variation begets spontaneity, which can ignite contributions and responses that otherwise would have been quite predictable, and admittedly, boring. Over the years, I have developed several approaches to conducting critiques.

THE INSTRUCTOR-LED OVERVIEW Each student passes their completed project to the individual to their right, and views the book given to them from the left. When finished, each passes the book on to their right. This circular viewing continues until the books are returned to their original owners. The instructor then initiates a commentary on the overall generalities seen within the group of solutions. Since the instructor has a comparative context from years of experience (which the students don't have), this approach provides a supportive frame of reference for students. Then, focusing upon individual solutions one at a time, the instructor links a specific aspect of a student's project to those original general comments, and, inviting student remarks, opens the way for a more in-depth analysis of each object as a whole.

THE WRITTEN APPROACH All participants are asked to write down a specific comment about each piece, based upon the project guidelines. Time is allotted for this. When all are ready, the instructor chooses a project to be discussed. One by one, each student reads their written comment. The student whose project is being discussed is encouraged to ask questions of the writer until they are satisfied in their understanding of the written comment. Often an interactive dialog ensues, with several students championing their assertion. When done, the same process is held for the next student, and so on. At the conclusion of the critique, each student is given all the written comments for their personal reference.

PAIRING OFF Students are assigned (or choose) a partner. Each looks at the other's project solution and must mentally prepare comments that speak to the strengths and weaknesses of the other's book, again in relation to the project parameters. Time is allotted for dialog between all the student pairs. At the conclusion of the time, each student "introduces" the other's book, with a summary of the shared dialogue that ensued. If there is time, other students are invited to comment as well.

"Articulation not only helps learners retain information, but it also 'illuminates the coherence of current understanding'"
—*T. Koschmann.*[2]

And assessment after production is beneficial, not just to evaluate existing work, but also to help plan future work.

"By forcing a student to actually commit to her knowledge of a subject, Articulation sets the stage for future opportunities of assessing and evaluating that knowledge."
—*T. Koschmann.*[3]

THE DISSECTION APPROACH Break down the objectives of the project into individual elements such as font choice/size, structural format, color palette, paper stock, use of negative space, pacing, etc. Assign each student one specific element. They must discuss that element's relationship to the concept of the piece, in all of the student solutions. As the critique progresses, this dissection approach quickly illuminates the integration of each element in the functioning of the piece, creating a greater gestalt.

RANDOM DRAW All books are numbered with a slip of paper and placed in the center of the table around which students are gathered. Students pick numbers from a hat, and match it with the appropriate book. They are given time to review the work, and consider it with regard to the project objectives. Each student is then asked to speak about the book they were matched with, offering positive observations first, and then suggestions for improvement.

THE SILENT APPROACH The student whose work is being discussed is not allowed to respond to comments made until the instructor senses that class comments have been exhausted. That student must practice listening skills, and may choose to take notes during the discussion. Then, inviting the student's response to the comments, the rest of the class listens. A round of dialogue ensues, and frequently results in deeper levels of consideration and evaluation. Since there is such a natural tendency to validate one's work with an immediate rejoinder, maintaining silence engenders self-control, and encourages would-be responses to fall into a fitting hierarchy.

THE ADJECTIVAL APPROACH Seated around a table, and having viewed all the works to be critiqued, the instructor conducts a round robin, asking each student to contribute an adjective that describes the work at hand. Depending on the number of students, this round robin may be repeated several times. Since students cannot reuse adjectives already spoken, there is an exigency to probe deeper. Very quickly the comments move from single words to insightful statements.

THE DEBATE APPROACH To begin, everyone looks at all books. Class is divided into two teams—A and B. Team A is given all of Team B's books, and vice versa. As a team, all members discuss each of the books they were given, with the intent to constructively criticize. Then deciding as to what they want to communicate, one member of Team A presents their case. Upon conclusion, Team B

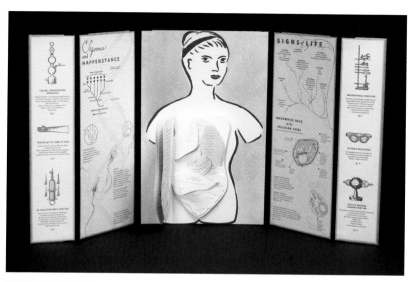

(Top) Casey Gardner, *Body of Inquiry*. Triptych structure holding a sewn codex within the subject's torso. Images hand drawn or taken from nineteenth- or twentieth-century laboratory catalogs, printed from photopolymer on Crane Lettra. 2011. (15" x 28" x 1".) Photograph by Luz Marina Ruiz.

(Bottom left) Jennifer Farrell/Starshaped Press, *Wood vs. Metal*. French Speckletone paper, wood and metal type, wood, and metal borders and ornaments. 2011. (12" x 9".) Photograph by Jennifer Farrell.

(Bottom right) Kay Michael Kramer. *The Artist and the Capitalist* by Florence Boos. Digital type printed with photopolymer plates, hand set type, and digitally printed William Morris letter. 2010. (9 ½" x 6 ½" x ¾".) Photograph by Kay Michael Kramer.

Assessing the Object Envisioned

is given a chance to rebut, and articulate their rationale supporting the decisions they made. When each book from the first team is critiqued, the process reverses and Team B presents. When finished, Team A is given the opportunity for rebuttal. Both art history and contemporary references to contextualize each team's statements are encouraged.

INSIDE/OUTSIDE APPROACH In an effort to prompt self-reflection as well as comparative assessment, students are asked to write down two sentences about their own book after viewing all of the books. The first is with regard to what concerns or doubts they had during the process of making the book. It should be stated in the form of a question ("Was I allowing enough of a transition between sections in the narrative with a single blank page?"). The second should situate their solution in relation to their peers' and be stated in the form of a declarative sentence ("I wish I had used a font with a smaller x-height, as John did, because it would have created a lighter visual weight to the copy block.") When called upon, each student reads their question, and the class responds, providing outside feedback for what began as a student's **interior** concern. The student then reads their second sentence, and more conversation ensues, triggered by the student's evaluation of his own work when viewed in the context of **outside** comparisons.

STUDENT-INITIATED APPROACH Inform the students well in advance that they will be directing their own critique; the instructor will serve as facilitator. Have them prepare a list of questions that they would like feedback upon. Emphasize that breadth and depth of commentary is directly in their hands. Provide guidance and pacing as necessary.

The Synergy of Form and Content

As these critique approaches are essentially methodologies to promote dialog, the instructor must always foreground the synergistic relationship of form and content. At every opportunity, whichever construct you are using, the formal elements or aspects being discussed should be linked to their role in elucidating content.

An example will serve us well here. Alyse Benenson, a student earning a dual degree in Fine Arts and Visual and Critical Studies had written her entire Bachelor's thesis from the heart-wrenching personal experience of recently losing a dear friend to an accidental overdose. Struggling to find a typographic approach for that section of the thesis that she intended to commit to letterpress, we engaged

(Top far left) Brian Borchardt, *Bold Strokes* (spread). Wood type on dictionary pages and banana leaf papers from the local Asian grocery store, and handmade paper. Bound with an open spine sewn in red string. 2009. (8¾" x 5½".) Photograph by Jeff Morin.

(Top left) Jerry Bleem, *Amended 22.7.* Polymer plate; thread (sewn collage), unique. Fragments of art magazines sewn on a black paper ground. 2009. (12⅞" x 12⅞".) Photograph by Tom Van Eynde.

(Bottom far left) Susan Makov, *Strategic Withdrawal.* 100 Printed on Rives BFK paper, in mauve ink, 50 in blue ink. A meditation by David James Duncan, author of *The River Why.* Duncan's idea about the piece was a dark sky showing Orion; Makov's idea was showing animals and plants that would be lost as the result of the human withdrawal of responsibility towards the world. The result was variations, all with the text reflecting the curve of a river. 2007. (24" x 14".) Photograph by Susan Makov.

(Bottom left) Susan Makov, *Strategic Withdrawal.* Variation: Dark sky: 46 printed on Magnani Pescia paper, blue/black and silver ink. 2007. (24" x 14".) Photograph by Susan Makov.

in a dialog. She had chosen to recount the clock-stopping, interminable moments during which she first learned of his passing, and the outrageously public manner in which she found out: posted on Facebook. Her anticipated text and our conversation vacillated between two extremes: her intense, intimate anguish and the multitudes of friends' clichéd postings about his passing. Clearly, the challenge was to give weight and importance to each of these "voices," while not overshadowing either, and create a visual compatibility as well.

As soon as we had isolated the vocal integrity of the piece, the typographic format revealed itself. Situating the small text from her intimate persona in a wide empty expanse of page mimicked the interior of her mind—entirely blank except for those few solid thoughts. Successively larger and more repetitive generic phrases, quickly build to a blinding density of incoherent copy on successive pages, so heavily layered that the pages themselves nearly warp. Leafing through the book thus dramatically reveals a "burial" of personal sentiment. But since the passage chosen had been illuminated by the grace of two years distance from the event, a final sobering sentence does emerge: *"We were of the same young blood."* Perhaps through the healing process of making the book, she had encountered an ultimate realization.

I would be remiss not to say that the critique of that book was a challenging one for the student to experience. It necessitated her reliving moments of agony. However, to her credit, her commitment to the formal elements of crafting the most eloquent letterpress book possible was equal to her emotional and cerebral investment in that very personal content. Her certainty in the typographic strategy, linked to the authenticity of the actual life experience was so evident during critique, that a palpable hush fell over the studio. And, in this instance, it was not a silence of non-participation; rather it was one of awe, respect and clarity of intent being communicated through the power of the printed page.

Notes

1 Edmund Feldman "Model of Criticism." In *Varieties of Visual Experience* (New Jersey: Prentice Hall, 1973).

2 T. Koschmann , CSCL: *Theory and Practice of an Emerging Paradigm* (Computers, Cognition and Work) (Hillsdale, NJ: Lawerence Erlabaum), 93. In "Articulation & Reflection" by Tina Harkness, Chandra Porter, Dana Hettich. Dept. of Educational Psychology & Instructional Technology, University of Georgia. *Emerging Perspectives on Learning, Teaching & Technology.* Michael Orey, ed. (CreateSpace Independent Publishing Platform, 2008).

3 T. Koschmann, CSCL: *Theory and Practce of an Emerging Paradigm,* 1995.

Alyse Benenson, *Of The Same Young Blood*. Letterpress book with waterfall binding, book cloth covered book board front and back covers, printed on Rives BFK, using Ehrhardt and Helvetica. 2010. (9 ⅖" x 14" x 1".)

CHAPTER TEN *Gallery of Letterpress*

10

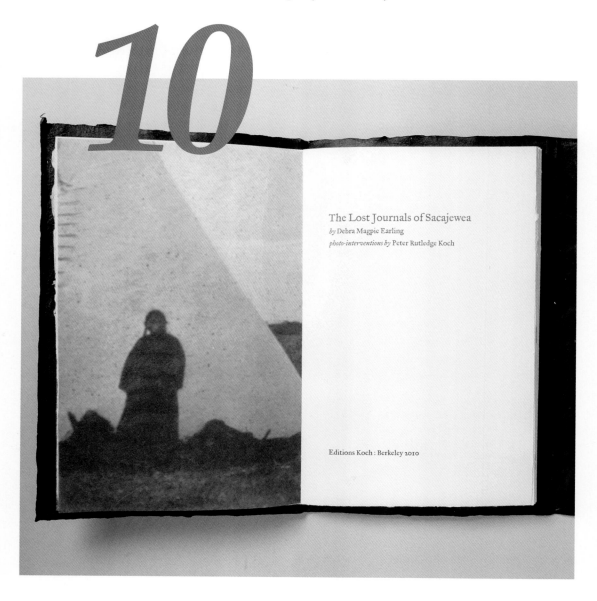

The Lost Journals of Sacajewea
by Debra Magpie Earling
photo-interventions by Peter Rutledge Koch

Editions Koch : Berkeley 2010

ooking at other artists' work is inspiring for both student and instructor alike. Over the next several pages you will find a diverse array of letterpress work, culled from over 2000 images, received from fifteen different countries around the globe.

Where possible, a portion of the artist's statement is included, so that the reader might glimpse the relationship of concept to structure, design and materials, through the artist's own words.

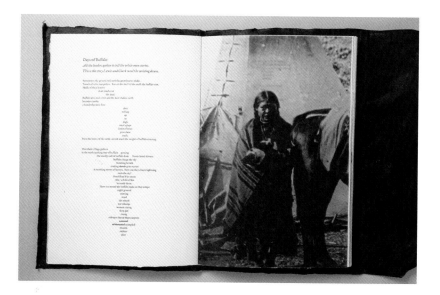

(Left) Peter Rutledge Koch, *The Lost Journals of Sacajewa* (title page).

(Top) Peter Rutledge Koch, *The Lost Journals of Sacajewa* (spread).

(Bottom) Peter Rutledge Koch, *The Lost Journals of Sacajewa* (closed). Designed, printed and bound at Peter Koch Printers. Text printed on Twinrocker Da Vinci handmade paper. Images prepared by Jonathan Gerken and Donald Farnsworth. Printed on Kozo handmade paper at Magnolia Editions by Tallulah Terryll. Bound by Jonathan Gerken. Smoked buffalo rawhide cover paper was designed and handmae by Amanda Degener. Spine beaded with trade beads and .38 caliber cartridge cases. Images flatbed acrylic digital printer. Published in Berkeley, CA by Editions Koch. 2010. (15 ½" x 10".) Photograph by Douglas Sandberg.

(Top and bottom right) Caren Heft, *Crossing the Tigris* (two spreads). Collaborative work with Jeff Morin and Brian Borchardt on Barcham Greene paper. Arabic dictionary end-papers. Gold stamping. 2011. (10 ½" x 6 ¾".) Photographs by Jeff Morin.

(Bottom) Peter Kruty, *I Had a Blueprint of History* (fig 9). Thirty pages of images by Lesley Dill that incorporate the entire text of the poem. The book is a collaboration between Lesley Dill, Sue Gosin, founder of Dieu Donné Papermill in New York, poet Tom Sleigh, the pulp manipulating genius of Dieu Donné's Paul Wong, and Peter Kruty Editions. "The horse unpierced (fig 9) pops from the copper background, but trompe l'oeil filmoplast tape tricks the eye into thinking horse and rider are a cutout. The book is built on dichotomies: real and 'fake', shiny and dull, wet and dry, transparent and opaque, airy and dense 'metal' ... and paper ... For the book, Paul Wong makes tissue thin abaca, elegant transparent abaca/cotton, metallic abaca silver, gold, copper and a mysterious butter yellow for the last page, each of these latter sheets dried against metal for a unique surface rustication." 2012. (18 ¾" x 14 ½" x ⅜".) Photograph by Taylor Photo.

They broke down the door just as the family was having dinner. They rushed in, weapons in their hands. Her father raised his hands, her mother collapsed on the floor weeping. Her brother flew into grandmother's embrace. They prodded her mother to her feet with their rifles and herded them to the back room. As she began to follow, one held his rifle in front of her, holding her in place. They stank, of unwashed male, of gun oil and of what must be liquor that she had heard that they all drank. She had smelled them from afar but never so close as now. Did all barbarians smell she wondered, unable to control her thoughts.

(Top) Jennifer Farrell/Starshaped Press, *Urbs In Horto*. Rustic, Railroad Gothic, Copperplate, Pen Print Bold type and metal ornaments on French Speckletone (18" x 14".) 2012. Photograph by Jennifer Farrell.

(Bottom) Katherine M. Ruffin, *Portrait of a Universal One: Vandercook No. 23654*. Mohawk Superfine. Variety of wood and metal types. 2008. (9¾" x 14".) Photograph by Steve Gyurina. "The image was improvised … I simply began printing the body of the press and continued to add elements. I printed a run then composed the next run and proofed, comparing proofs to the actual press …The broadside gave me the opportunity to experiment with varnish, metallic inks and overprinting ... I can see that I was responding to constructivist typography, and oil portraits of individuals, to which I always gravitate in art museums. Most significantly, I was able to express my excitement about printing (note the use of exclamation points for the main operator's controls)." Original edition of 100; reprinted

Portrait of a Universal One
Vandercook No. 23654

Reprinted for MATRIX 28 at Shinola Press by Katherine McCanless Ruffin in 2008

in an edition of 800 with Jesse Marsolais of Firefly Press, Boston, MA. "We printed from the original type, not plates, on the Universal One."

(Top) Diane Jacobs, *Wig #5* (front). Hand-set type printed on black paper. Wooden turned spindles by Steve Jacobs. One-of-a-kind. "By hand setting and carefully letterpress printing degrading and racist words that make my blood boil I learn to own them and the power they once had dissipates. I challenge the viewer to question why these words exist and how we use them." 1999. (28" x 9" x 9".) Photograph by Bill Bachhuber.

(Bottom) Diane Jacobs, *Wig #5* (detail). 1999. (28" x 9" x 9".) Photograph by Bill Bachhuber.

(Top) María José Prenafeta, *Friday* (hidden poster). 2008. (8⅖" x 5½" x ½".) Photograph by María José Prenafeta.

(Bottom) María José Prenafeta, *Friday* (close-up of tearoff). Wood type, printed with linoleum blocks and photopolymer plates on handmade abaca paper in three colors. Hidden poster: 16" x 9⅗" when unfolded. Drum leaf binding. The reader must tear open a page in order to be able to read the entire text. This is a metaphor for the violation of intimacy that occurs when we eavesdrop on others: mirrored in the violation of the book's integrity by the reader. 2008. (8⅖" x 5½" x ½".) Photograph by María José Prenafeta.

(Top) Alessandro Zanella, *Poesie Verticali* (title). Fourteen poems by Maria Luisa Spaziani; seven relief prints handcut on polymer plates by artist Marina Bindella, set with digital type Trinité by Bram de Does. Printed on Hahnemühle paper from photopolymer plates. 2009. (12⅘" x 8¼".) Photograph by Alessandro Zanella.

(Bottom) Alessandro Zanella, *Poesie Verticali* (spread). Photograph by Alessandro Zanella.

For the Love of Letterpress

(Top) NewLights Press: Aaron Cohick, Kyle Schlesinger, et al, *What You Will* (interior spread). 2011. (8 ¾" x 9 ⅛" x ⅜".) Photograph by Aaron Cohick.

(Top left) NewLights Press: Aaron Cohick, Kyle Schlesinger, et al, *What You Will* (text spread). 2011. (8 ¾" x 9 ⅛" x ⅜".) Photograph by Aaron Cohick.

(Bottom left) NewLights Press: Aaron Cohick, Kyle Schlesinger, et al, *What You Will* (open). Poems by Kyle Schlesinger. Object by NewLights Press: Aaron Cohick, et al. Letterpress printed on French Paper from photopolymer plates. "We say that the book is a time-based form because it takes time to move through a book … When content begins to crawl over the pristine surface of the pages the multiplicity becomes far more chaotic. Now the ideal measure of the page is inflected, varied … The covers were made by printing every single plate from the pages in white, on black paper, in exactly their position on the page, showing the entire open book at once. The jacket contains all of the information that would normally be on the jacket of a book (title, author's name, press name, etc.) collapsed and layered into single lines and in two reversed arrangements. The book functions in, and demonstrates, both idealized, spatialized time, and indivisible, overlapping duration." 2011. (8 ¾" x 9 ⅛" x ⅜".) Photograph by Aaron Cohick.

11

The *Oxford English Dictionary,* in its poetic and timeless way, defines letterpress printing as material printed from a relief surface. Relief printing is that in which the printing surface stands in relief, that is, above the surrounding non-printing area. It defines relief as a vividness, distinctness, or prominence due to contrast or artistic presentation. It is sustenance, support of a place. It is assistance towards saving or affecting something.

How does a Letterpress Studio work its invisible magic? Why is it that, we are not surprised, when a student, upon entering the Type Shop for the first time, exclaims immediately "This is my favorite room in the building!" In fact, we find it downright normal.

The evidence of care in our Shop is communicated to even the most casual observer. Everyone feels it, from the first-time visitor to the student on the very first day of class. The student who spends a semester or more in the shop becomes a part of it.

Why? For the love of it. The love of pulling open a timeworn drawer of foundry type, picking up a shiny character and feeling for that telltale nick. The love of scraping a spatula through a thick puddle of crimson ink. The love of running one's fingers across the back of a sumptuous sheet of handmade paper, freshly imprinted with a perfect punch.

There is something innately satisfying in these simple gestures. They go back to our basic human instincts of making marks, recording our existence, testifying that we are here. They correspond to the sensuality of our very being. Letterpress speaks with a voice that resonates in tune with that physicality.

And therein, lies its certainly for survival. The flashing glow of a computer monitor does indeed dazzle the eyes. But letterpress is deeper. Sculptural. Three-dimensional. Not every student continues on in life doing letterpress, although some definitely do, acquiring tons of equipment on their own. The lure of digital type, the flat LCD screen, the page layout that doesn't require glue or wax or hours of setting type by hand, beckons, and hypnotizes. Understandably so.

But to those who choose to learn and engage in the process of letterpress, whether it be for a semester, a day's workshop, or a lifetime, letterpress stands in relief, metaphorically just as the *Oxford English Dictionary* defines it, in contrast to the flat printout. Students studying art and design find that it provides sustenance by exciting the body and the mind. It gives them a chance to work and touch

(Left) Cathie Ruggie Saunders and Martha Chiplis, *Letterpress Luminaries* Detail (open). Conceived and printed as a keepsake guide in conjunction with the College Art Association A Case for Letterpress Panel, Chicago, 2010. "Designed and printed at The School of the Art Institute of Chicago Letterpress Type Shop, in honor of those individuals whom we look up to, those who have helped us on our way, a constellation (of magnitude) familiar in Chicago's letterpress universe." Printed on Vandercooks in three colors from handset type and plates, on Japanese paper, with a wrapper made of discarded maps. 2010. (10" x 3½".)

(Right) Cathie Ruggie
Saunders and Martha
Chiplis, *Letterpress
Luminaries* (closed).

(Far right) Cathie Ruggie
Saunders and Martha
Chiplis, *Letterpress
Luminaries* (open).

directly the type designed by Caslon, Goudy, and Zapf, and to use it without being able to distort it with one key command. While letterpress is making a lasting impression on the hearts and minds of generations to come, those generations are assisting in the very saving of it. They are supporting its place in college and university curricula, in community centers, design firms, and makeshift studios across the world. Falling in love with lead adds the voice of "heavy metal" to contemporary design's digital chorus. And it ensures that the sensual, hand-printed artifact called a book will be carried forward yet another century. All for the love of letterpress.

APPENDICES

Further Reading

Art of the Printed Book: 1455–1955 Masterpieces of Typography Through Five Centuries From the Collection of the Pierpont Morgan Library New York (NY: David Godine, 1978).

Bright, Betty, *No Longer Innocent: Book Art in America 1960–1980* (NY: Granary Books, 2005).

Castleman, Riva, *A Century of Artists Books* (NY: Museum of Modern Art, 1994).

Chappell, Warren, *A Short History of the Printed Word* (MA: Nonpareil Books, 1980).

Duncan, Harry, *Doors of Perception: Essays in Book Typography* (TX: W. Thomas Taylor, 1987).

Drucker, Johanna, *The Century of Artists' Books* (NY: Granary Books, 1995).

The Holy Bible, Containing the Old and New Testaments: Translated out of the Original Tongues and with the Former Translations Diligently Compared and Revised by His Majesty's Special Command; Appointed to Be Read in Churches. Two volumes. Designed by Bruce Rogers. (Oxford: Oxford University Press, 1935).

Homer, *The Odyssey* (London: Bruce Rogers, Emery Walker and Wilfred Merton, 1932).

Ikegami, Kojiro, *Japanese Bookbinding* (NY: Weatherhill, 1986).

Lawson, Alexander, *Anatomy of a Typeface* (NY: David Godine, 1990).

Lawson, Alexander, *Printing Types: An Introduction* (MA: Beacon Press, 1971).

Lyons, Joan, *Artist's Books: A Critical Anthology* (NY: Visual Studies Workshop Press, 1986).

McGrew, Mac, *American Metal Typefaces of the Twentieth Century* (DE: Oak Knoll, 1993, 2009).

Moxon, Paul, *Vandercook Presses: Maintenance, History and Resources* (AL: Fameorshame Press, 2011).

Rehak, Theo, *The Fall of ATF: A Serio-Comedic Tragedy* (WV: Pioneer Press, 2004).

Rummonds, Gabriel, *Printing on the Iron Hand Press* (DE and UK: Oak Knoll & the British Library, 1998).

Simon, Herbert, *Introduction to Printing: The Craft of Letterpress* (London: Faber & Faber, 1968).

Smith, Esther K., *How to Make Books* (NY: Potter Craft, 2007).

Smith, Keith, *The Structure of the Visual Book,* revised ed. (NY: Visual Studies Workshop Press, 1992).

Steinberg, S. H., *Five Hundred Years of Printing* (New Edition revised by John Trevitt, DE and UK: The British Library & Oak Knoll Books, 1996).

Tracy, Walter, *Letters of Credit: A View of Type Design* (NY: David Godine, 1986).

Tschichold, Jan, *The Form of the Book* (Vancouver, British Columbia: Hartley & Marks, 1991).

Twyman, Michael, *The British Library Guide to Printing History and Techniques* (Toronto: University of Toronto Press, 1998).

Wilson, Adrian. *The Design of Books* (CA: Chronicle Books, 1993).

Glossary

Arm Short horizontal strokes, as in E, F, L, T or inclined upward as in Y, K.

Bed The flat surface of a printing press on which the type form rests.

Brass Thin space, 1 point thick, used for spacing type.

Brayer A small roller for inking type on a proofing press.

Cabinet (Type Cabinet, Stand) The support for cases, often with a tilted top.

Case A wooden tray with compartments for storage of type.

Chase A rectangular steel or iron frame into which a type form is locked for printing.

Colophon An inscription placed at the end of a book or manuscript usually with facts relative to its production. From Latin (via Greek) *kolophon,* summit, finishing touch.

Composing stick Tool for receiving lines of type as they are picked out from the case.

Composing stone A very smooth and flat surface made of stone or steel for assembling a form in a chase.

Copper Thin space ½ point thick, used for spacing type.

Counter The enclosed or partially enclosed negative space (white space) of some letters such as d, o, and m.

Cut A term for a block of illustration of any kind.

Display Type sized approximately 16 point and over.

Distribute The term for returning type to its proper compartment after printing.

Dummy A sample of a proposed work, made up to the correct number of pages and cut to the correct size.

Em The square of a type size. Only in the 12 point size does this equal 12 points.

En An equivalent in width to one half of an em.

Font In metal type, a complete set of a particular size and design of type including lower case, capital and small capital alphabets, figures, and punctuation marks.

Form The page or pages of type and cuts locked in the bed or chase ready for printing.

Furniture Wood or metal blocks used to fill up any substantial blank spaces in the bed of the press.

Galley A metal tray with one end open which type composed in a stick is transferred.

Guillotine A machine with a sharp knife for trimming edges of books and pamphlets, and for cutting stacks of paper down to the required size.

Hair space Very thin spacing for between-letter and between-word spacing.

Justification The act of setting type to the exact measure so that individual letters are neither too slackly or too tightly packed together.

Kerning A component of letterspacing, used to remedy problems between letter pairs. Manual kerning involves taking away type metal to allow two letters to sit closer together.

Key Tool for loosening or tightening metal quoins.

Leads (or leading) Strips of type metal used for between-line spacing.

Letterspace To add space between individual letters.

Ligature A combination of letters which form one piece. Examples are: ff, fl, ffl, fi, ffi.

Lockup The fitting of quoins into a form and tightening so that type and furniture are held firmly in place.

Makeready The preparatory work done on the cylinder or platen of the press to get type and illustrations to print evenly.

Mockup A full-sized structural model built to scale chiefly for study, testing, or display. Also a working sample for reviewing format, layout, or content.

Nick Indention in the top side of type used to identify the correct orientation.

Offset Unintentional transfer of ink (as from a freshly printed sheet). Offset can be avoided by interleaving or allowing ink to dry before sheets are piled up.

Ornament A small, decorative element cast in type metal.

Packing Paper that is stacked behind or underneath the tympan to achieve the desired amount of pressure or punch.

Pica There are 12 points in a pica and approximately 6 picas to the inch.

Pi To spill or throw (type or type matter) into disorder. If you don't tie up your type in your galley it will easily become pied.

Plane A block of wood polished flat on one side and usually with a protective pad of leather on the opposite side, used to tamp down the form.

Platen A flat plate that exerts or receives pressure as in a printing press.

Point A typographical point measures .01384 of an inch. There are 12 points in a pica. 72 points is approximately equal to 1 inch.

Proof Any trial print of composed type or illustration.

Quads Abbreviation for quadrats which are large spaces (below type height) for filling out blanks and short lines. Quads are usually 1 to 4 ems wide.

Quoin An expanding wedge of metal used to exert pressure on furniture in type forms.

Register The exact adjustment of position so that printing on the front of a page corresponds with the printing on the back. Also the exact fitting of one color with another.

Reglet Narrow wooden furniture, 6 point or 12 point in thickness.

Rule Type high lengths of type-metal for printing straight lines.

Sans serif A style of type that has no serifs.

Serif The beginning or ending stroke drawn at an angle across the arm, stem, or tail of a letter.

Slug Strip of spacing material 6 points thick and greater.

Slur A smudged or blurred impression in printed matter.

Spacing 12 pt. spacing for 12 pt. type, 18 point spacing for 18 point type, etc. Spacing is made in different widths to fill out the horizontal distance in a composing stick.

Stem All vertical strokes of a letter, and full-length oblique strokes as in V, W, and Y

Tail Short downward strokes, as in K and R. The term is used for the Q, even when it is a curved horizontal stroke.

Text Type sizes usually 14 points or smaller.

Tympan Smooth treated paper that has a very even thickness and is placed between the cylinder or platen of a press and the paper to be printed.

Type high .918 inches in the US and England.

Typeface The face of printing type or all type of a single design.

Additional Resources

VIDEOS

Firefly Press (printing video)
www.youtube.com/watch?v=Iv69kB_e9KY

Stan Nelson on Typefounding
www.youtube.com/watch?v=eExllUe
Gtvc&feature=related

TYPE FOUNDRIES

The Dale Guild
http://thedaleguild.com/

M & H Type
www.arionpress.com/mandh/

Bixler Press and Letterfoundry (Monotype)
http://www.mwbixler.com/

PAPER SUPPLIERS

Dolphin Paper
http://store.dolphinpapers.com/

Daniel Smith
www.danielsmith.com/

New York Central Supply
www.nycentralart.com/

Legion Paper
Place an order 212.683.6990 x302
info@legionpaper.com
www.legionpaper.com/

INK VENDORS

NA Graphics
www.nagraph.com/

Van Son Holland Ink
www.vansonink.com/pages/
Letterpress.html

Graphic Chemical and Ink
https://www.graphicchemical.com/

PLATEMAKING

Boxcar Press (photopolymer)
www.boxcarpress.com/

Royal Graphix (magnesium)
www.royalgraphix.com/

Owosso Graphic Arts
(magnesium and copper)
www.owossographic.com/

PRINTING EQUIPMENT

Dave Churchman
www.sterlingtype.com/

eBay (search "letterpress" under the
category of "Printing & Graphic Arts")
http://www.ebay.com/

MUSEUMS

Hamilton Wood Type and Printing Museum
www.woodtype.org/

Platen Press Museum
www.platenpressmuseum.com/

Hatch Show Print
http://countrymusichalloffame.org/
our-work/

PRINTING ORGANIZATIONS

American Printing History Association
www.printinghistory.org/about/mission-
history.php

Fine Press Book Association
www.fpba.com/

Ladies of Letterpress
http://ladiesofletterpress.ning.com/

College Book Art Association
www.collegebookart.org/

PUBLICATIONS

The Devil's Artisan
http://devilsartisan.ca/

Parenthesis, the Journal of the
Fine Press Book Association
www.fpba.com/parenthesis/about.html

Printing History, the biannual journal of the
American Printing History Association
www.printinghistory.org/publications/
printing-history.php

Ampersand, the quarterly journal of
the Pacific Center for the Book Arts
http://pcba.info/publications/ampersand-
archive/

Book Arts Newsletter, published every four to
six weeks at the Center for Fine Print Research,
edited by Sarah Bodman
www.bookarts.uwe.ac.uk/banlists.htm

VANDERCOOK & LETTERPRESS SUPPLIES

NA Graphics
www.nagraph.com/

BINDING SUPPLIES

Talas
www.talasonline.com/

Hollanders
www.hollanders.com/

BOOK FAIRS

Codex
www.codexfoundation.org/

Pyramid Atlantic
http://pyramidatlanticbookartsfair.org/

Oak Knoll Fest
www.oakknoll.com/fest/

ONLINE COMMUNITY

Briar Press
www.briarpress.org/

Book Arts List (subscribe to digest)
https://listserv.syr.edu/scripts/
wa.exe?A0=BOOK_ARTS-L

Photopolymer List
http://groups.yahoo.com/group/ppletterpress/

Letterpress Listserv
(subscribe to digest or nomail
and read the archives)
https://listserv.unb.ca/cgi-bin/
wa?A0=LETPRESS*Letterpress Commons*
http://letterpresscommons.com/

HEALTH & SAFETY

HSE British independent health
and safety organization
www.hse.gov.uk/printing/index.htm

OSHA (Occupational Safety and
Health Administration)
www.osha.gov/SLTC/printing_industry/
index.html

PRESS REPAIR /
TROUBLE SHOOTING

Vanderblog
http://vandercookpress.info/vanderblog/

SCHOLARSHIPS / FUNDING

Caxton Club
www.caxtonclub.org/scholarships.html

College Book Art Association
www.collegebookart.org/

KickStarter (search "letterpress" to see
the letterpress projects currently funding)
www.kickstarter.com/

Index

Colophon

This book was designed by Martha Chiplis and Cathie Ruggie Saunders. It was laid out by Martha in Adobe InDesign CS5 on a Mac Mini. The type is Palatino Linotype by Hermann Zapf.

Palatino was punchcut in metal in 1950 by August Rosenberger at D. Stempel AG type-foundry in Frankfurt am Main, and then adapted for Linotype machine composition. It was later adapted by Zapf for photocomposition, then digital composition.

"(Palatino was) ... named after the Italian writing master of the sixteenth century in Rome, Giovanbattista Palatino, a contemporary of Michelangelo and Claude Garamond. (I hope Palatino may one day forgive me in heaven and give me his blessing for using his good name for my typeface)." — Hermann Zapf, *linotype.com*